COLCHESTER

THE POSTCARD COLLECTION

JESS JEPHCOTT

AMBERLEY PUBLISHING

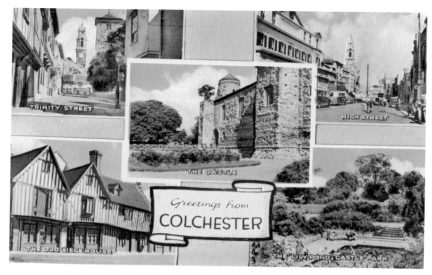

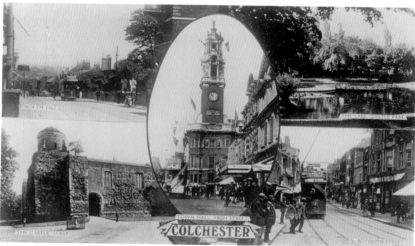

First published 2014

Amberley Publishing
The Hill, Stroud, Gloucestershire, GL5 4EP
www.amberley-books.com

ISBN 978 1 4456 3667 2 (print)
ISBN 978 1 4456 3685 6 (ebook)

British Library Cataloguing in Publication Data.
A catalogue record for this book is available from the
British Library.

Typesetting by Amberley Publishing.
Printed in Great Britain.

CONTENTS

Introduction 4

Town Centre: Within the Walls 6

Town Centre: Outside the Walls 23

The Castle, the Hythe and Lexden 47

Lexden 64

The Garrison 69

Miscellaneous View 84

Maps of Colchester 89

INTRODUCTION

THE SELECTION

Colchester has a history that is second to none. That may seem a boastful statement, but it is true. While our history stretches back thousands of years, historical records date from AD 77 when one Pliny the Elder, a Roman scholar, mentioned *Camulodunum* (our ancient Roman name) in relation to a sighting of the aurora borealis in Britannia. While the postcards that you will find in this book are comparatively recent, dating from the early twentieth century, they stand as a testament to our long and fascinating history, as you will see.

Picture postcards, of the type we have here, date from 1902. At half the price of the Victorian 'penny post', they were a cheap, easy and attractive form of communication. It was possible to send a local card in the morning, knowing that it would be delivered to the intended recipient on the same day. Postcards were the email of the day. At first, they were in black and white due to a lack of cost-effective colour photography. A system of hand colouring was developed to increase the attractiveness of the image, later followed by true colour photography. With so many men away from home during the First World War, the postcard was hugely important for keeping in contact with loved ones. After the War, postcards went into decline, by comparison, but still remain a way of sending happy tidings to friends and family.

The cards that have been chosen for this book are a selection of the assortment available. As this book is about Colchester, rather than the more specialised cards depicting people, churches, shops and pubs, I have concentrated on the best views of our street scenes and landmark buildings. Earlier views, which take in the period of the First World War, are also brought into focus. Colchester possessed one of the biggest Army garrisons in the country at that time and many cards were sent from this location. The postcards chosen for this collection can be seen to reveal progress as it unfolds across the town, with particular emphasis on the 'honeypot' areas that were so popular with the townsfolk and the postcard producer.

SOURCES OF PICTURES

The vast majority of the postcards in this book are from my collection. A few images, depicting particular scenes that I have found difficult to replicate, have been donated. Reference to this has been made in the acknowledgements section.

MAPS

The map section, which indicates where the different views are, or were, to be seen, should assist the reader. For instance, a map of tram routes has been included to supplement the many pictures of trams. Starting at our earliest historical point, the maps show how the town has developed over the centuries, accumulating ancient features bequeathed by the Romans, Saxons, Normans, Tudors, Stuarts, Georgians and Victorians, many of which have survived to this day.

A BIT OF OUR HISTORY

Colchester, the oldest recorded town in Britain, was a well defended settlement known as *Camulodunum*, which was ruled over by the all-powerful Cunobelin until the Roman Emperor Claudius came in the year AD 43. Taking the surrender of several British chiefs, he began his conquest of Britain. In his name, a fortress was built on top of a hill that overlooked the indigenous people, known by their tribal name as the Trinovantes. They had the good sense to live on lower ground, close to the water of what we know today as the River Colne and the Roman River. Very soon after, the Romans probably judged that the British people were resigned to their new masters and unlikely to cause trouble. The decision was taken to convert the military fort into a colonia, the highest order of Roman settlement where retired Roman soldiers could live and, when push came to shove, could be relied upon to support Rome's interests. Then came the destructive attack by Boadicea (or Boudicca) in AD 60, which precipitated a magnificent wall being built around the colonia. It remained under Roman rule until around AD 410, when it appears they all went home. The Romans had created Britain's first city, something that Colcestrians take great pride in today.

When the Normans came after 1066, they would have found a collapsed, decayed and empty citadel, perhaps 'built by giants', from a time gone by. This place, with its incredible walls, was of immense importance to the Normans for its defensive potential, and was to provide the location for the largest Norman castle ever built. As the Romans before them had quickly found, there were no natural building materials here. They had been forced to harvest a hard clay material known as 'septaria' that had to be brought from the coast, some thirty or so kilometres away. The limestone for mortar had to be brought from even further afield. The fuel for baking the red, boulder-clay bricks and for making the lime mortar was provided by the wood from the huge forest that covered much of this area at that time. In constructing Norman Colchester, the Normans made use of the Roman materials that lay all around them, efficiently destroying Roman Colchester while preserving the all important, strategically-defensive walls.

The Romans created Colchester as Britain's first city and the Normans gave us so much of what we see today. Today, Roman tiles and septaria are to be seen in most of our old buildings, especially in churches and monastic buildings .

This book of postcard views shows how Colchester has evolved over the centuries since the Romans came and built their colonia almost 2,000 years ago. Here you will see evidence of the Roman period, from the basic street layout and defensive walls that they bequeathed to us, to their materials that were reused by later generations to create our heritage buildings.

We cannot begin to explore these images of Colchester with anything other than our most important thoroughfare; our High Street. To follow, we will stay within the Roman colonia walls, observing different street views, before moving outside the walls to view streets beyond the centre. Certain parts of the town are of particular interest, so I have created separate sections for such subjects as the castle, the Hythe and Lexden. Since the late eighteenth century, the military garrison has also played an important part in shaping our town. I hope that you enjoy the selection that I have made for you and the commentary that accompanies them.

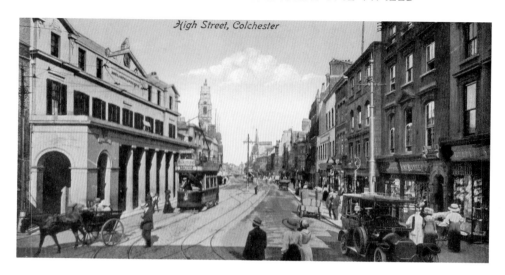

High Street, Colchester

The High Street

We start our postcard views with the oldest street in the country. Our High Street was originally laid out by the Romans in an east–west orientation on the hill that overlooked the surrounding area. Their *via principia* became our main town thoroughfare, where shops, inns, markets, churches, offices and general trades were to be found. Here, we see two similar views of a bustling street scene from around 1905: the Essex and Suffolk fire office to the left; tram number three making its way east; our imposing town hall (only completed in 1902) and the spire of St Nicholas church in the distance. Two contrasting pictures show the new-fangled motor cars, electric-powered transport and, of course, the horse and carriage.

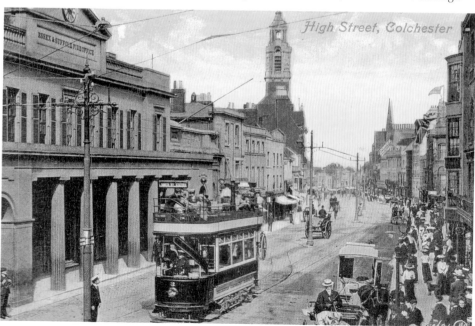

High Street, Colchester

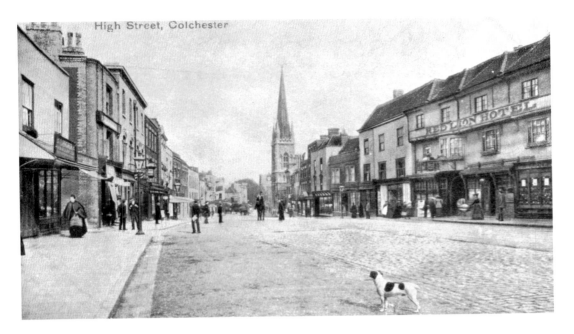

The High Street

Proceeding eastwards a little further along the High Street, we turn to look back and see, on the right, one of the oldest timber-framed buildings in Colchester, the Red Lion Hotel. Once home to the Dukes of Norfolk, it later became an inn of good repute. The absence of tramlines in the road suggests a date preceding 1904, when trams were introduced to Colchester. Below, dated 1934, we have a more direct view of this ancient fifteenth-century or sixteenth-century inn. The archway is elaborately carved with St George and the Dragon, an indicator that the owner was awarded the Order of the Garter. Along the street, we have Kendall & Sons, with their red umbrella sign, and Lawrence's Outfitters. Messrs Sainsbury's shop was next door, before it grew into the nationwide giant of today.

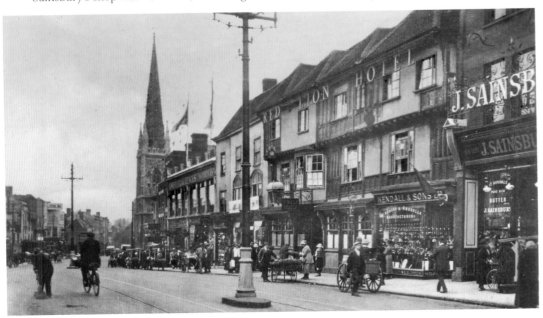

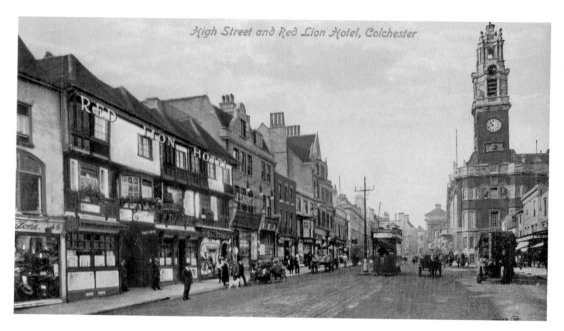

High Street and Red Lion Hotel, Colchester

The High Street

Turning back on ourselves and looking westwards, we catch sight of the Red Lion Hotel in 1916, with a view on the right of a steam engine, horse and cart, and a tram. An early motor car stands in front of Sainsbury's and closer inspection of our magnificent town hall reveals the town's patron saint. Saint Helena was the mother of the Roman Emperor Constantine who brought Christianity to us in the fourth century AD. In the distance, we get a glimpse of 'Jumbo' (more on that later). Below, in another bustling scene from the same direction taken in the 1940s, we can see two-way traffic as it passes Burston's wine and spirits shop, Freeman, Hardy & Willis, and, further along on the left, F. W. Woolworth.

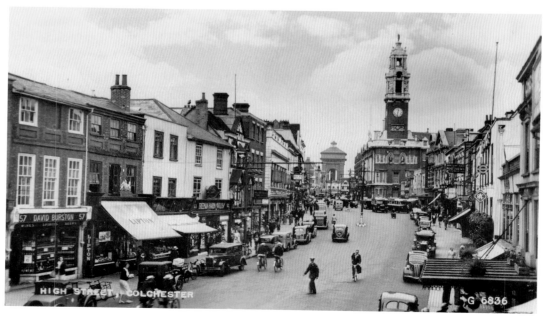

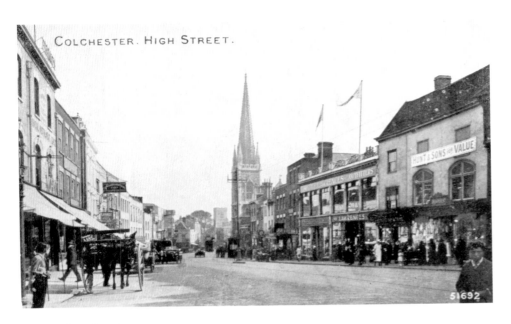

St Nicholas Church

Continuing in an easterly direction, we see once more the imposing spire of St Nicholas, a Victorian creation by famed architect of the day Sir George Gilbert Scott. A lively political scene existed in Colchester at the time. This church was built to be the tallest building in the town, intended to beat the record set by the non-conformist, and therefore Liberal, church of Lion Walk (in its turn, the tallest some decades before). Sadly, this situation was not to last, as St Nicholas was demolished in the 1950s due to redundancy and replaced by a very lacklustre building known as St Nicholas House. Part of the old church's graveyard still exists in St Nicholas Square. These two postcards give similar views and both show All Saints church in the distance.

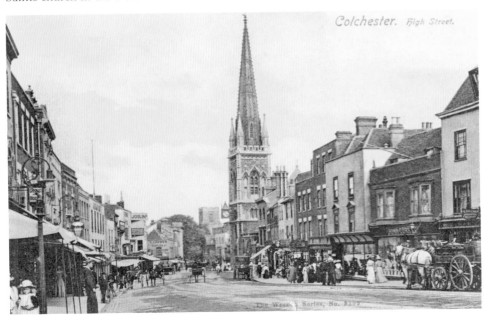

Colchester. High Street.

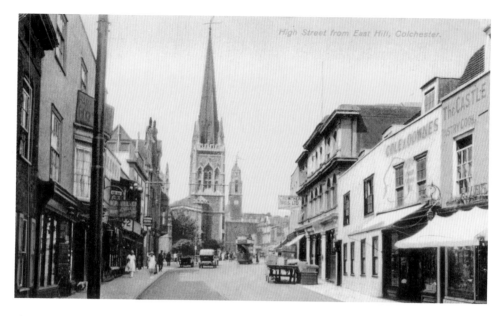

High Street from East Hill, Colchester.

The High Street Churches

Looking back westwards, having passed St Nicholas church, we get a glimpse from the 1940s of the town hall and nearby shops. These include what is now one of the largest and most prestigious companies in Colchester, Messrs Kent Blaxill. Below, taken from the same direction further east, we see All Saints church to our left (now our Natural History Museum). The building to the right was demolished in the 1920s to make way for the new war memorial. From the Norman period through to the medieval, Colchester became divided into parishes, each with their own church as the focal point. Eight churches stood within the walls with four outside. So far, we have seen two of them and have skipped over another; St Runwalds once stood in the High Street, close to the town hall.

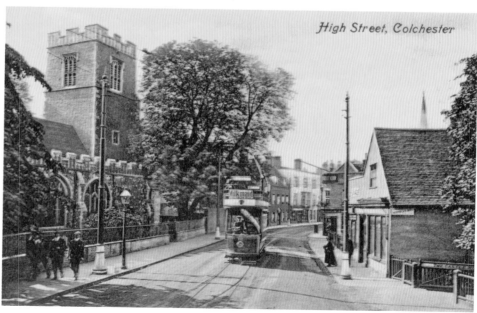

High Street, Colchester

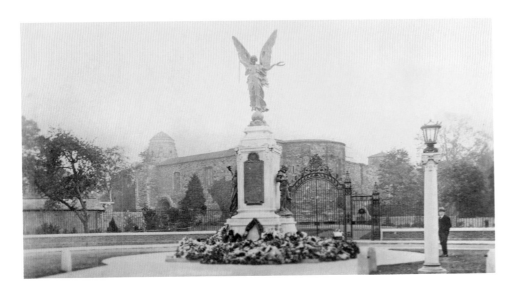

High Street and the War Memorial

A short distance away from All Saints church, across the road, is our wonderful war memorial, designed by Henry Fehr in the 1920s. It is now the focal point of our annual Remembrance Day service, when hundreds of people come to remember those that gave their lives in the First and Second World Wars and other conflicts. On top is a bronze statue of Victory, flanked on one side by George and the Dragon (representing the men of the town) and Peace (representing the women). Behind the monument, the gates are dedicated to Lord Cowdray, who donated Castle Park as part of this war memorial. In the background is our splendid Norman castle – more on which later. Below, we stand at the end of the High Street looking west, with the Minories on the left and the building known as the Gate House on the right. A short way to the west of us is the town wall and the beginning of East Hill.

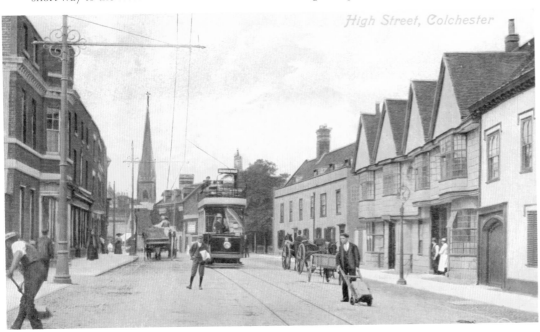

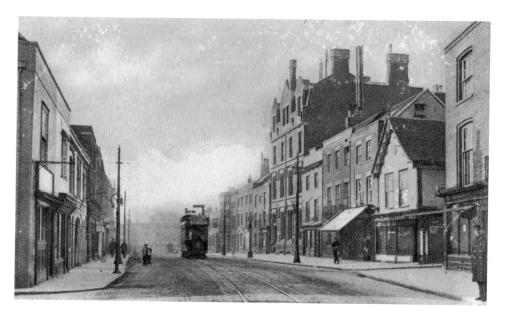

Head Street

As we leave the High Street at its west end, we find another of the major original Roman thoroughfares, Head Street, leading to one of the original five main Roman gates into the colonia. In the opposite direction, we have North Hill. Head Street has a true north–south alignment and the view above looks south towards Headgate in around 1905. The tall central building, then our main post office, was more recently converted to a cinema and shops. The view below is from further along the street, still looking south. The Roman gate is long gone but would have been where the carriage stands. The Head Gate Hotel faces us, with Crouch Street off to the right and St John's Street to the left.

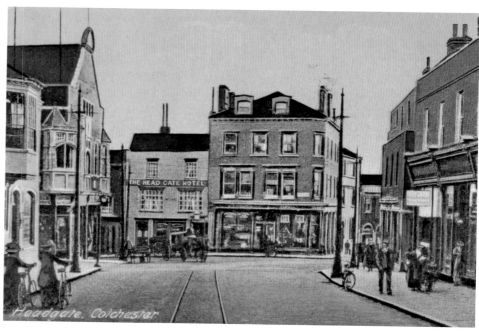

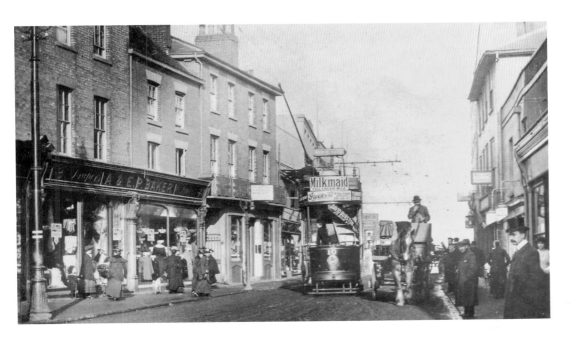

Head Street and Headgate

Above, we have a view looking north, with a characteristic street scene from 1910 of a tram, horse and cart, and a gentleman with whiskers and a top hat. The premises of A. & E. P. Baker are on the left. Below, we have another view looking north and from the 1930s, with the trams long since done away with and the motor car beginning to rule the streets. On the south corner of the road to the right was the house of Sir Isaac Rebow, MP for Colchester at one time, after whom the street on the right is named. This picture was taken at the position of the Roman gate that we now refer to as Headgate. The most important gate of its time, it led to the road bound for London. Sir Isaac's Walk therefore follows the line of the Roman wall's rampart, where Roman soldiers would once have stood guard against attackers.

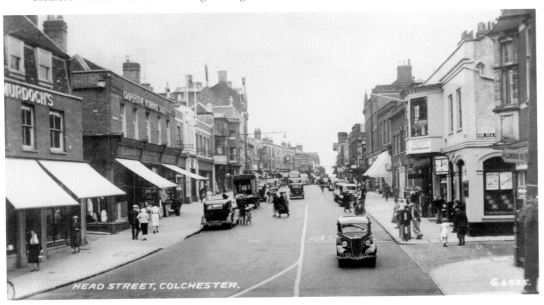

HEAD STREET, COLCHESTER.

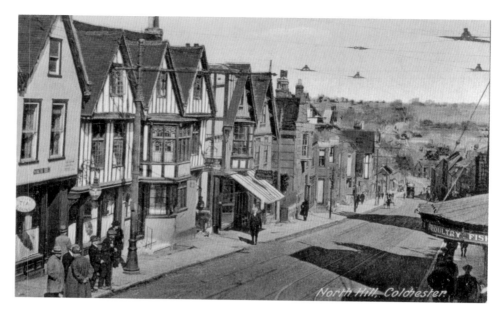

North Hill

Standing again at the west end of High Street, but this time looking north, we have the continuation of the Roman thoroughfare that would have led down to the Roman North Gate and, a short way beyond that, the River Colne. The above view, dated around 1910, shows a tram taking its long haul up the hill, with the ancient Waggon and Horses inn, as was, on the left. It was here that cockfighting became the pastime of 'gentlemen' when many a bet was won or lost. The view below shows a tram having reached the top of the hill and the church of St Peters. This church, the oldest recorded, holds ascendancy over all our other churches and has a reference in the Domesday Book in around 1086. Damaged by an earthquake in 1690 and again 1884, it has been much rebuilt and is the fourth church within the walls that we have seen so far.

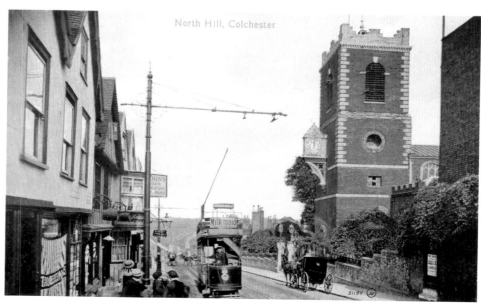

North Hill, Colchester

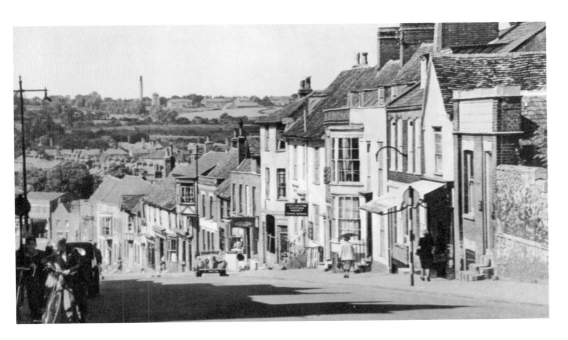

North Hill

People who come to visit Colchester realise fairly soon that it is built on a hill. This was purposefully done by the Romans for reasons of defence. North Hill is perhaps the most challenging for pedestrians and horses alike, with the trams too ascending with some difficulty at times. The above card is from the 1950s and shows an area that could be considered as belonging to the more well-to-do businesses in town, lawyers in particular. This is still the case today, but with the addition of several excellent eateries. The first building on the right used to be the registry office where many Colcestrians took their vows of marriage. The view below is a similar one, but from the opposite side of the road.

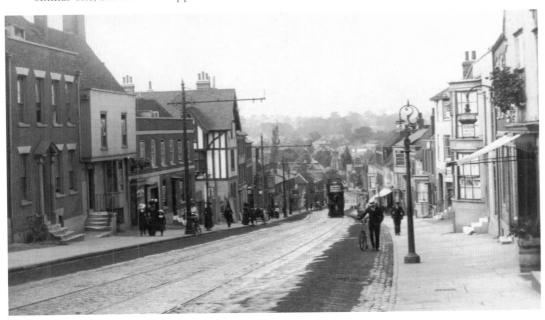

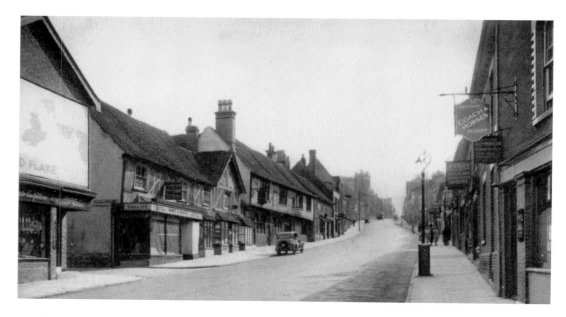

North Hill

This view is from the foot of North Hill looking south. There are some fine ancient timber-framed buildings on the left-hand side, one of these being the Marquis of Granby pub. Once the home of a wealthy merchant, it later became a tavern known as the Crown, before changing its name in the 1780s in recognition of the bald-headed marquis. A visit inside is a must for visitors to the town as, inside, there are exquisite examples of fifteenth-century to sixteenth-century carvings, perhaps only matched by those at Paycockes in Coggeshall. On the right hangs the sign of the Coach and Horses pub. It was built hard up against the Roman wall, which was on show inside the pub for all to see. The pub is now gone, but the wall remains the only remnant of where the North Gate once stood. The view below looks south and up the hill, with the old cattle market on the right.

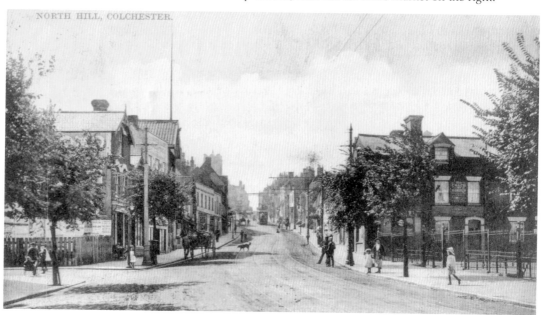

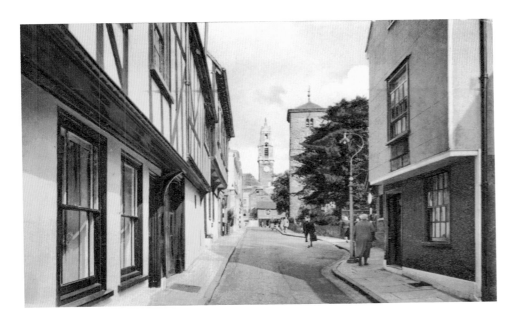

Trinity Street

Trinity Street has a lot of charm, with ancient timber-framed buildings and the oldest building in Colchester, the tower of Holy Trinity church. The above view looks north along the street, with jettied buildings either side. The church at the top of the street intersects with Culver Street West, with the magnificent Victoria Tower of our town hall in the distance. Almost opposite the church, on the left hand side, is an alley that opens out into a wonderfully hidden garden belonging to the house we know as Tymperleys (shown below). Here once lived William Gilberd, a son of Colchester, who, in Tudor times, experimented with and coined the word 'electricity'. He became physician to Queen Elizabeth I, and is believed to have been buried within the church grounds.

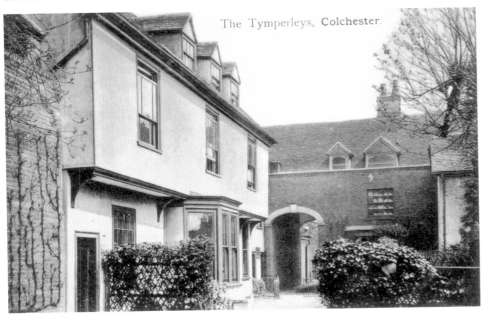

The Tymperleys, Colchester.

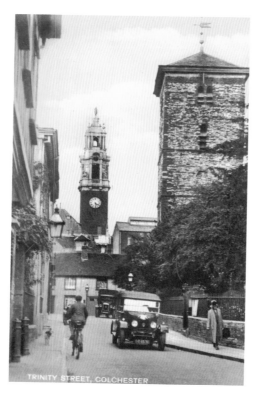

TRINITY STREET, COLCHESTER

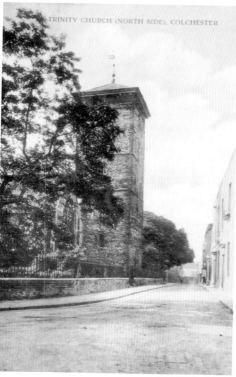

TRINITY CHURCH (NORTH SIDE), COLCHESTER

Holy Trinity

Here we have a closer view of Holy Trinity church and its tower, in particular, which is of characteristic Saxon design and was built around the year 1000. Whether or not it was originally built as a lookout tower and later became a church, we cannot be sure. What we do know is that it was built with the extensive reuse of Roman building materials, Roman brick and septaria, which would have been easily found at that time from the decayed remains of the deserted colonia. The tower has a superb arrow-arch doorway on its west side and a heavy oak door to match, as well as 'basket' windows. Built before our Norman castle, it would have been the tallest building in the settlement at one time. The church was deconsecrated some decades ago and became our Social History Museum before its closure. The view above looks north and the view below south. This is our fifth 'within the walls' church.

The Weavers' Quarter

Many centuries ago in Europe, a wave of religious awakening led to conflict with Roman Catholicism. People known as Huguenots were welcomed in England and many came here and settled in this area of Colchester. They were often Flemish weavers who established themselves here as creators of some of the finest cloths, known as bays and says. As a result, from the Middle Ages to the seventeenth century, Colchester became one of the top six wealthiest towns in England because of the wool trade. Many of the timber-framed houses here date from between the fourteenth and seventeenth century, and are built from oak or elm that was not wanted by the navy yards. Here we have two views looking north. The one below is of a wealthy person's home at one time.

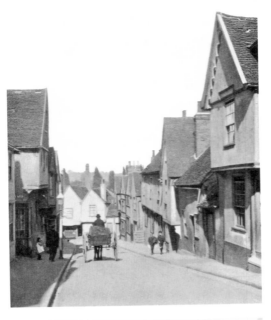

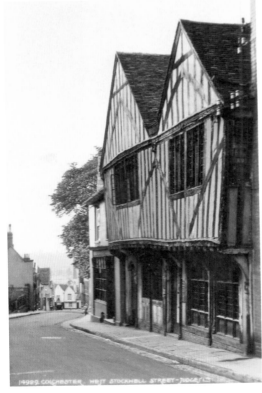

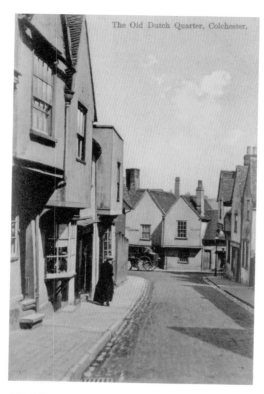

The Old Dutch Quarter, Colchester.

West Stockwell Street

The upper storeys of these houses jut out into the road, a sign of wealth to impress and to give more room upstairs. The original windows, where they survive, were especially large to assist the weaver at his or her work in a time when electric lights had not yet been invented. The view above looks north and follows one of the Roman thoroughfares, as do so many of the roads within the walls. The view below is from the bottom of the street and looks south, with the town hall in the distance. In this area would have been the stock well, where the local people would have drawn water for everyday use. Remember, Colchester was originally built on a hill as a fortress. Water was a secondary requirement and had to be fetched from lower ground where the natural springs were to be located.

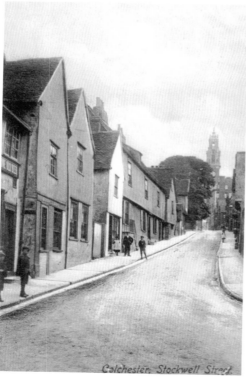

Colchester, Stockwell Street.

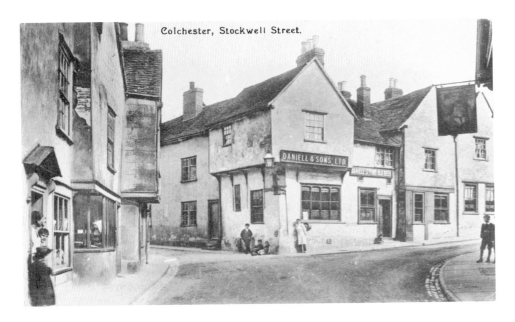

Colchester, Stockwell Street.

West Stockwell Street

At the foot of West Stockwell Street stood two pubs, the Stockwell (as it is named today) in the centre here, and the Admiral Nelson on the right. You can just make out the head of that naval hero of the Battle of Trafalgar on the pub's sign. It is said that there is a connection between Daniel Defoe, the famous eighteenth-century writer, and the Stockwell building, from a time before it became a provider of the product of Sir John Barleycorn. Was this once his home? Below, we have a view of St Martin's church in the heart of the Weavers' Quarter, which spread over a wide area that included East Stockwell Street, Maidenburgh Street and Northgate Street. Our sixth of the eight medieval churches within the walls of Colchester, this one was much damaged during the Siege of Colchester in 1648. This church has a 'leper's squint'.

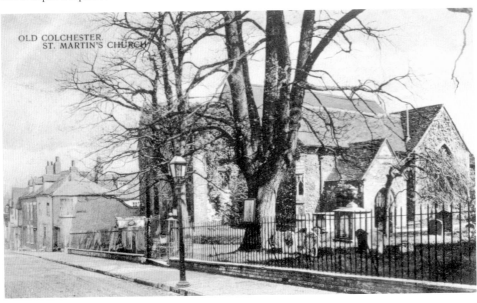

OLD COLCHESTER.
ST. MARTIN'S CHURCH

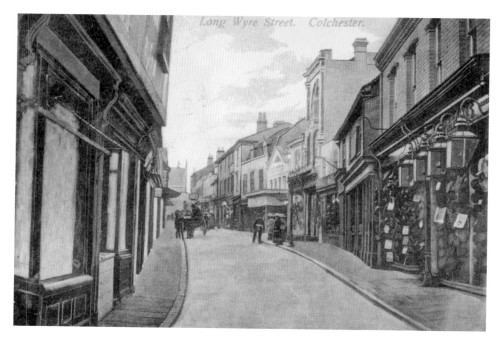

Long Wyre Street

Long Wyre Street is another of our ancient and narrow streets, much changed over the years. The picture above shows a range of shops, with the sign of the Rainbow public house just discernible on the second building along on the right. It was closed in 1922 following trouble with misbehaving soldiers. Close by, there used to be one of Colchester's theatre halls or playhouses, so popular in those days with young and old alike. In both views we are looking north.

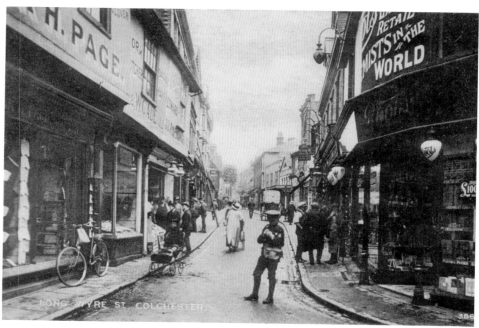

Balkerne Hill

Balkerne Hill, built by the Romans after Boudicca's destructive visit in AD 60, runs alongside the west face of Colchester's Roman wall. The 2,800-metre-long wall is around two thirds intact and makes an interesting walk for those so inclined. The borough has responsibility to maintain the significant Scheduled Ancient Monument. The above picture shows a small section of the wall, but also some of what is left of the Balkerne Gate, one of the five main access gates into the colonia. Some centuries later, somebody built a pub on top of the wall and named it the King's Head. However, when the railway came to Colchester in 1843, the landlord saw fit to knock a hole in the wall to afford his customers a view of the new railway. The pub was given the nickname 'the Hole in the Wall', a name that still applies today. The view below shows the Jumbo water tower and one of the four passageways through the Balkerne Gate.

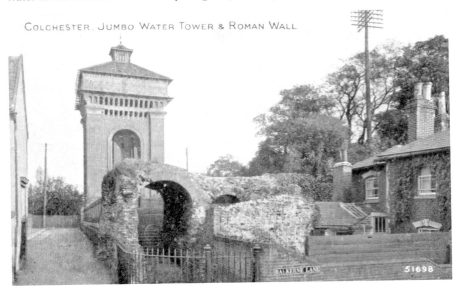

COLCHESTER, JUMBO WATER TOWER & ROMAN WALL

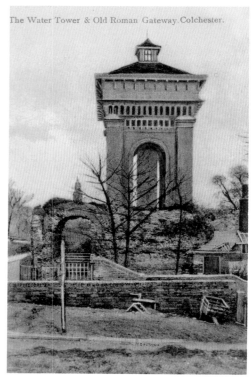

The Water Tower & Old Roman Gateway, Colchester.

Jumbo Water Tower and Balkerne Gate

Jumbo, completed in 1883, was intended to be the answer to the town's water shortage and the control of waterborne diseases. Water was pumped to it from the foot of Balkerne Hill. It was named by Revd Irvine, who likened it to one of the elephants that happened to be in town at the time with a travelling circus, and still stands today in all its glory, looking for a new use. In the two pictures, we also see some of the remains of what we know as the Balkerne Gate, so named because it was baulked or sealed off at some stage in history, probably by the Normans, judging by the standard of the work. The gate fell out of use because it was sealed off, resulting in it now being the best-preserved Roman gateway in Britain. Also, the section of the *via principia* (later to become our High Street) that would have linked this gate with East Gate disappeared, so our High Street starts, or stops, where it does.

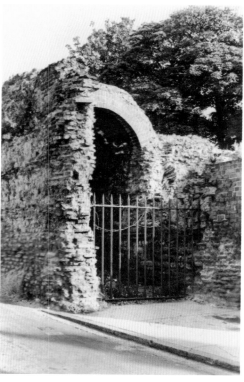

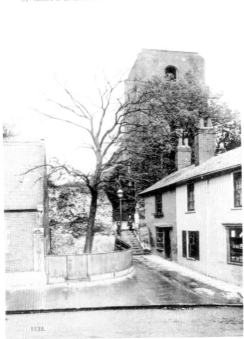

St. Mary-at-the-Walls, Colchester

St Mary at the Walls Church

A short distance away, to the south, we have St Mary at the Walls church, the seventh of our eight churches that are within the walls. This church was much damaged by parliamentarian cannon fire during the Siege of Colchester of 1648, when a group of Royalists set themselves up in the town in opposition to the rule of Oliver Cromwell's government. We are told that a Royalist gunner was placed on top of the church tower and was doing quite a bit of damage to the besiegers. So much cannon fire was brought to bear on him that he came tumbling down, giving rise to a claim that this event was the origin of the Humpty Dumpty nursery rhyme. The tower was later repaired in brick rather than the original stone. Needless to say, the Royalists lost the fight. Their leaders were executed in the castle grounds and the King lost his head. Nevertheless, these two views show a delightful scene of bygone days.

"OLD COLCHESTER"
ST. MARY'S CHURCH AND OLD TOWN HALL

1138.

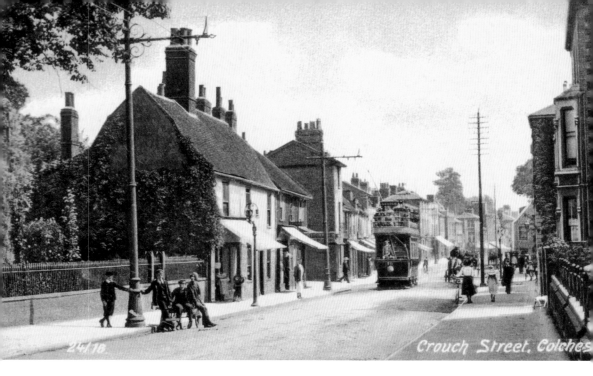

Crouch Street

Crouch Street follows the route that was once the Roman road between Camulodunum and Londinium, or as we say today, Colchester and London. It takes its name from Crouched Friars, a medieval friary that once stood at the south-east end of the road. The trams took this route as far as Lexden to the west. The above view is looking east, and the one below west.

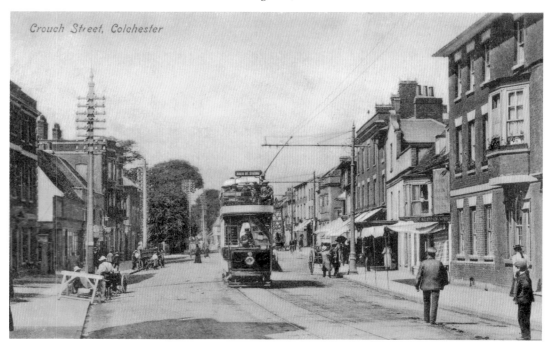

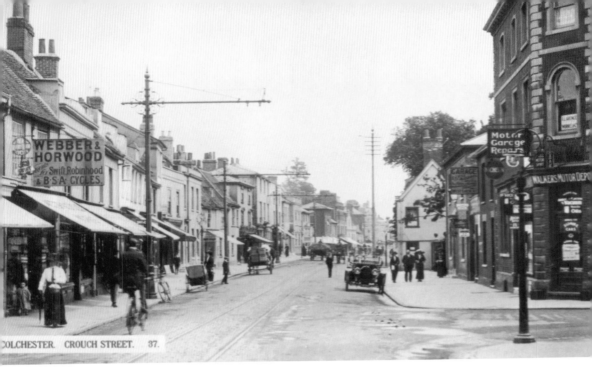

COLCHESTER. CROUCH STREET. 37.

Crouch Street

Today, Crouch Street looks very different, having been split in two by the widening of Balkerne Lane and the construction of the Maldon Road roundabout in the 1970s. The east-facing view above dates from 1914, with the premises of Webber & Horwood on the left and Walkers Motor Depot on the right. The west-looking view below dates from 1911, with the policemen of the day standing at Headgate. The Bull Hotel is a short way along the road on the left.

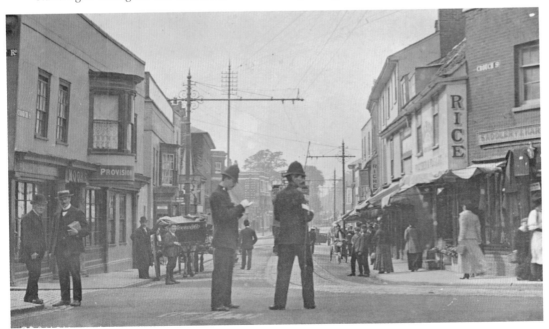

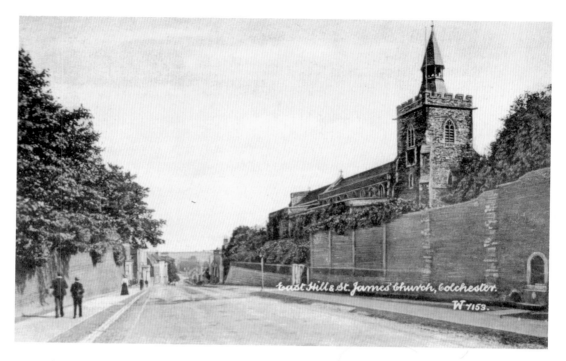

East Hill

From the top of East Hill, looking east, the above picture shows the last of our eight parish churches within the walls of Colchester, St James the Great church. On the far right we see a drinking fountain, so important in the days when drinking water was not available to everybody in their houses. This road is one of our Roman roads, and would have been much steeper at one time before it was lowered in the seventeenth century. This occurred coincidentally with the removal of the Roman east gate, which stood immediately east of the churchyard and stands high in relation to the road. The picture dates from before 1904, when trams were introduced. The later view below shows a view further down the hill, with Priory Street on the right.

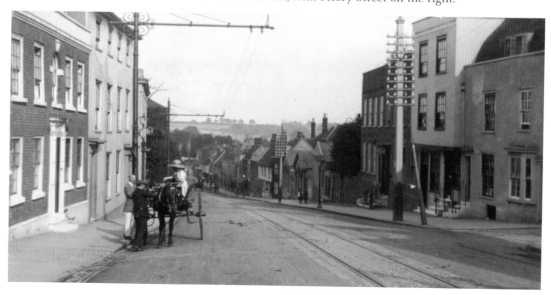

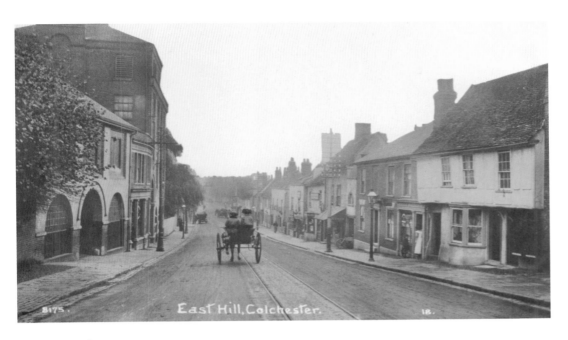

East Hill

East Hill was the location of various breweries, notably those of the Colchester Brewing Company and of Messrs Charrington Nicholl. The picture above shows the former, on the left hand side. The whole route down to Eastgates (as it is known today, due to the railway crossing that is there) has many fifteenth-century to sixteenth-century timber-framed buildings. This was an area where the poorer classes lived in the Victorian period, with many side alleys and courtyards crowded with families. The view below, as we turn around to look back up the hill in a westerly direction, dates from 1918. The sign on a shop on the left reads, 'A Cater, bird stuffer and confectioner'. The tall building in the distance on the right is part of Colchester Brewing Company's brewery building. The spire of St James the Great church can also be seen.

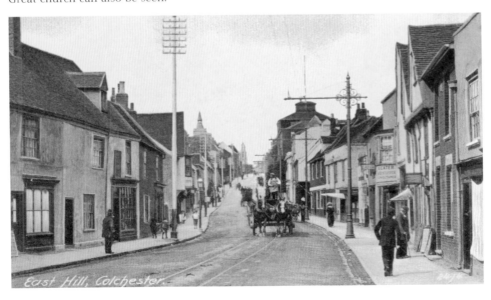

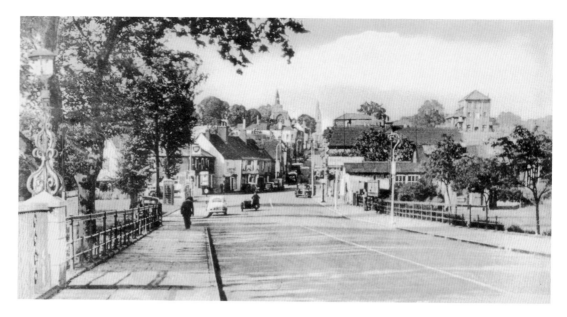

East Bay, East Bridge and East Mill

Moving further east, we come to East Bay and East Bridge. The view above is from the 1960s and looks west towards the town centre. Next to the bridge, eastwards, was East Mills, also known as Marriage's Flour Mill. The mill buildings have since been converted to private dwellings. The mill owner was presented with quite a difficulty in dealing with the milled products. In order to reach the mill by water, it was necessary for the boats coming up the River Colne, via the Hythe, to lower their masts to pass under the bridge. It was as a consequence of being on the wrong side of the bridge, presumably, that the ford from ancient times was replaced. The view below shows the mill from the air. It would have been powered by the flowing water of the River Colne, the freshwater millrace weir holding back the tidal flow of the salt water from the nearby sea.

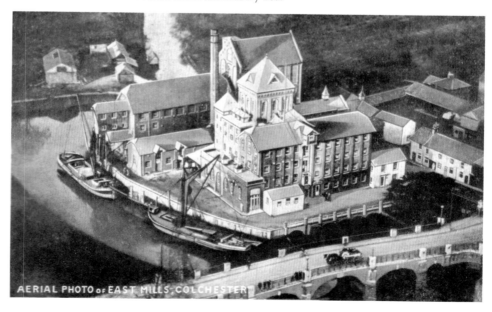

AERIAL PHOTO of EAST MILLS, COLCHESTER

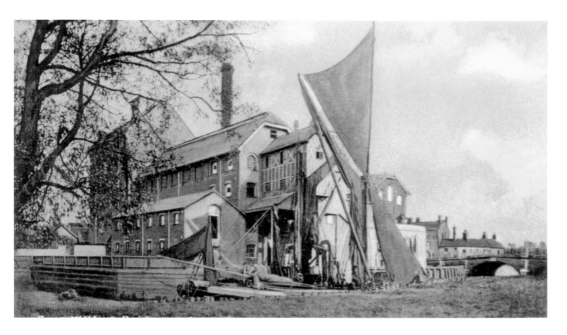

East Mill

These two pictures show East Mill (one of several mills in Colchester) at ground level with a Thames barge, as they are known in these parts, having negotiated the tricky business of getting under the bridge. It then had to raise its mast again in order to offload and load its cargo. Horses would have been used to pull the boats up and down the river. Other mills in the town, according to references made in manorial records, date back to at least the twelfth century. They were either windmills or water powered (and later, steam powered), used for grinding grain or for fulling the all-important cloth that was being produced in the weaving quarter of the town, as previously mentioned.

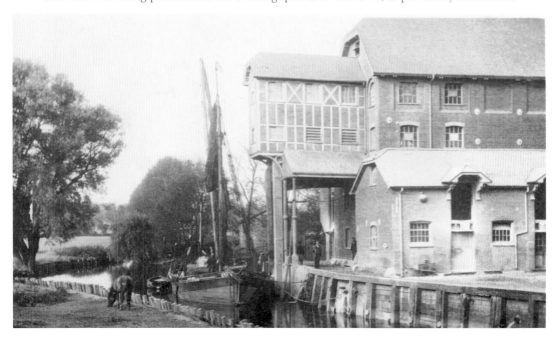

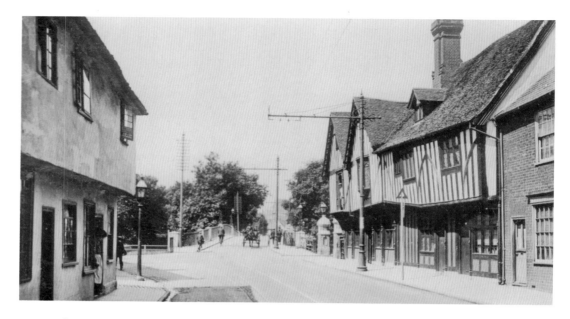

East Bridge and the Siege House

Fronting the road, alongside the mill, is a much loved timber-framed building, known today as the Siege House, so called because of the bullet holes in the fabric dating from the time of the Siege of Colchester in 1648. The number of bullet holes and whether they were put there by Royalists, Parliamentarians, or both are now lost with time. Later, owners appear to have added small red rings to show off the holes and enhance the legend. The upper floor of the building was used for storing corn or flour; the transportation horses and carts pulled up below the first-floor doorway to be loaded. Most of the buildings along this section were, and still are today, of great age. The view above looks west towards East Bridge, with the Siege House the last on the right.

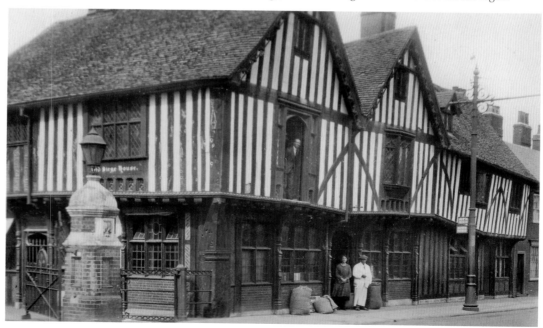

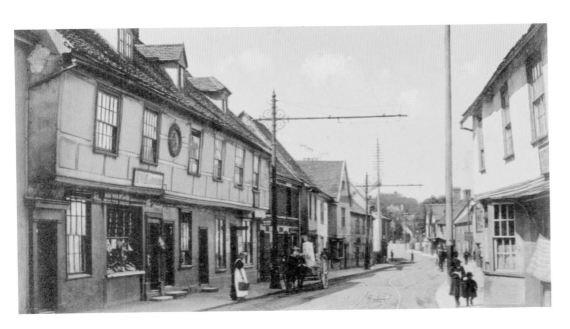

East Street

The view above is of East Street, looking west. This part of the town had its own community of housing, shops, and pubs. The Welcome Sailor public house is on the right side, with Ipswich Road just beyond that and out of view. Below, a little further along to the east, but looking west, our postcard shows us the wonderful old Rose and Crown, as was. This was much used in the eighteenth and nineteenth centuries by drovers bringing sheep and cattle to the market that was then in the High Street. The mayhem and mess caused by the animals as they were driven through the streets is hard to imagine. The inn closed for a while in 1910, before reopening as one of today's finest pub-restaurants after extensive restoration by Mrs Faithfull Roper in the 1950s.

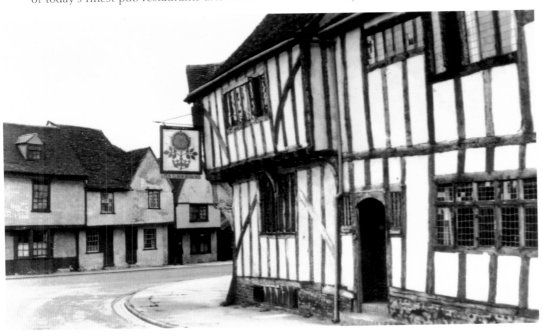

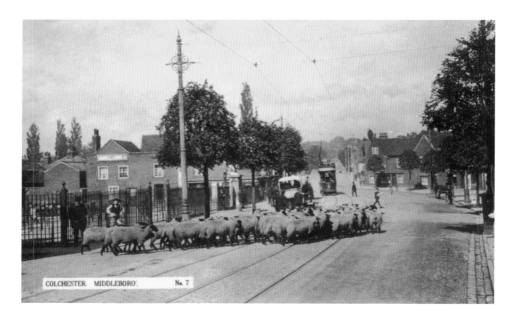

Middleborough

Colchester's new market was introduced in Middleborough in 1862. Before that, cattle and sheep had been driven through the streets and into pens set up in the High Street. One can just imagine the smell, the dust, the filth and the growing resentment from the townsfolk. Eventually, it was all moved to a specially constructed permanent market at the foot of North Hill. The picture above, from around 1915, looks north and shows a herd of sheep being taken away, a tram having just passed through. The picture below is also looking northwards and gives a view of the Newmarket Tavern (as it was appropriately named) on the left, and houses on the right that were swept away many years ago. The market was moved to Severalls Lane in 1975. Pubs in the vicinity did a roaring trade when extra opening hours were granted.

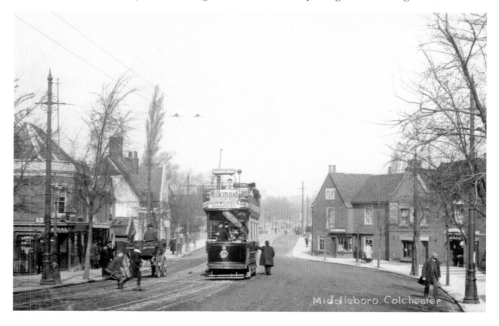

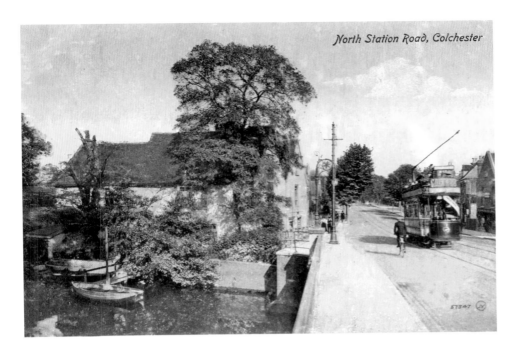

North Station Road, Colchester

North Bridge

Just to the north of Middleborough, we find the River Colne and North Bridge. Above, we have a typical view looking north with a tram having just crossed the bridge and heading for the terminus at North station (LNER railway station). The building to the left was the Castle Inn (or the 'North Castle', as the locals knew it, to distinguish it from the other pub of that name in the High Street). Below, we have an example of a heraldic postcard, showing Colchester's borough arms, the three crowns of the magi and the sprouting cross of Christ, all allegedly discovered by our patron saint St Helena, mother of the Roman emperor Constantine, who brought Christianity to these isles in the fourth century. It also shows another view of North Bridge with plenty of the boating activity that used to go on in those bygone days.

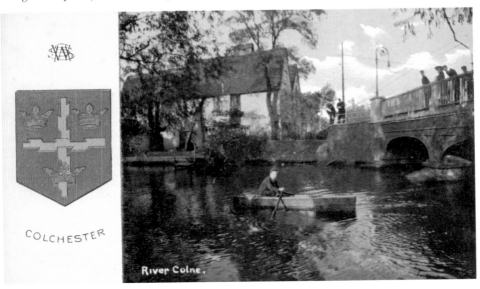

COLCHESTER

River Colne,

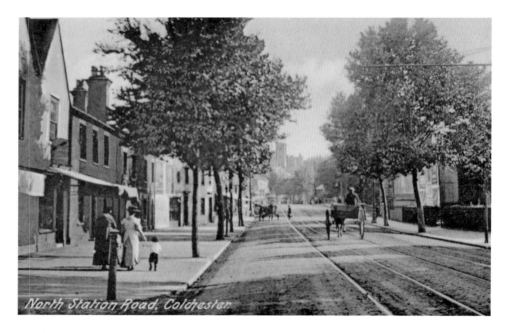

North Station Road

Further north, we come to North Station Road and a delightful view above of an almost traffic-free highway, quite unlike the view today. One can almost hear the clippety-clop of the pony and trap, with a flat-capped gentleman and his young son out for a ride. This view looks south towards the town. North station, as opposed to St Botolph's station, was first opened in 1843. It was built 'out of town' for fear of the smell and the noise that it would have caused to the more genteel folk of the town. Thereupon, a brisk trade sprung up to meet passengers alighting from their train and convey them into town to more agreeable surroundings (and to be parted from their money by eager tradesmen). The view below is another street scene.

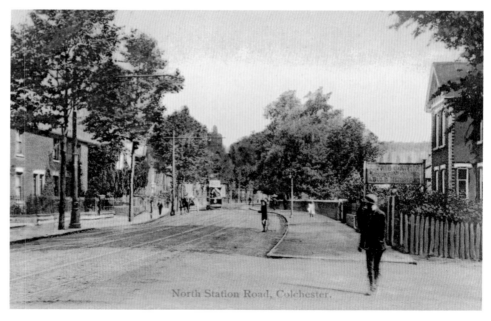

North Station Road, Colchester.

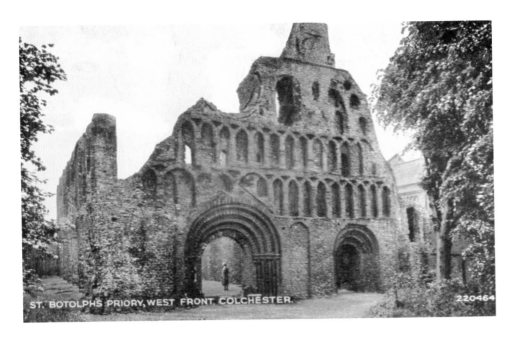

St Botolph's Priory

This area was another favourite of the picture postcard maker. St Botolph's priory was founded in 1105 and was the very first Augustinian priory in Britain. It suffered considerably when King Henry VIII brought about the dissolution of the monasteries in the sixteenth century and was damaged again by parliamentarian cannon fire during the siege of Colchester in 1648. Today, the grounds are laid out very nicely and are open to the public. The view below gives a view from the inside of this much decayed building, which is maintained as an important public monument. The priory builders made extensive use of recycled Roman materials during its construction. The metal railings around the various tombs went towards the war effort!

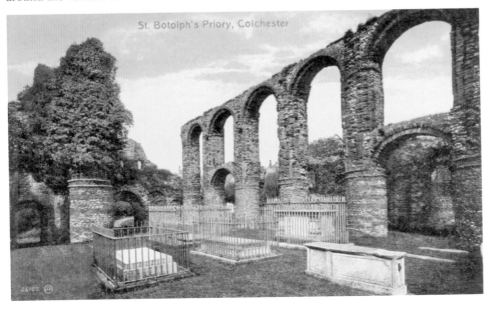

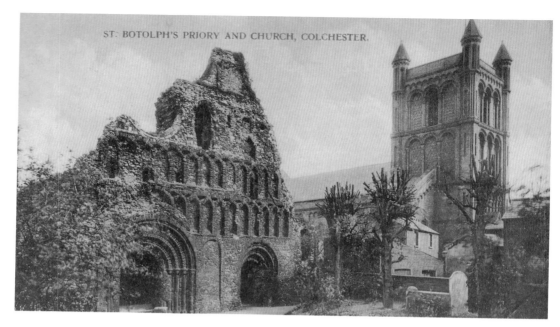

St Botolph's Church and Mersea Road

The priory was accompanied by one of the four ancient Colchester churches that are outside the walls of the city. Both these buildings can be seen in the picture above. The church may look medieval, but it was only completed in 1838 in the Norman style, and replaced the much-decayed church that once stood there. The card below gives us a view in a northerly direction from Mersea Road, looking towards St Botolph's. On the left is the Norman wall of St John's abbey, not a Roman wall as the card suggests. On the right is the old vaudeville theatre, now long gone. In the distance, we see what used to be known as Plough Corner at St Botolphs, an area much changed today. It was in the 1970s that the borough decided to cut a swathe through much of old Colchester to create our modern-day Southway.

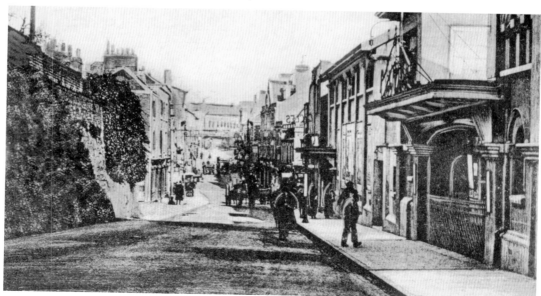

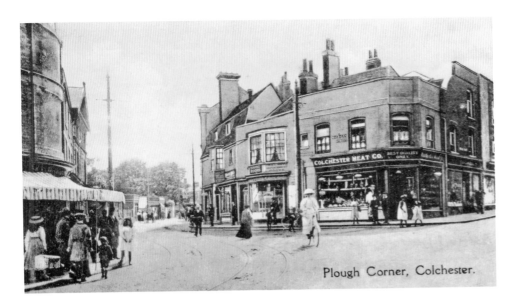

Plough Corner, Colchester.

Plough Corner and St Botolph's Street

The picture above shows Plough Corner some time around 1912, a view that is quite unrecognisable today. To get our bearings, we must imagine that Mersea Road is off to the right and Magdalen Street is to the left. The Plough public house is on the corner of the two streets, slightly around the corner to the right. The only building that is clear in this picture and still stands today is the gable end of the Fountain pub on the left, later to have several names, Molly Malones perhaps being the most memorable to most. The tramlines head off toward Military Road and to the terminus at the Recreation Hotel, as was. The view below takes us north and up a way along St Botolph's Street. We are looking back southwards with Plough Corner in the distance and Vineyard Street on the immediate right. A bustling street scene!

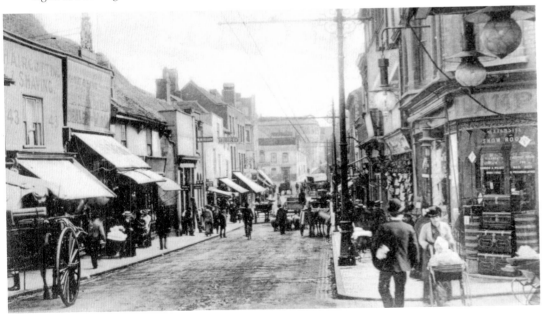

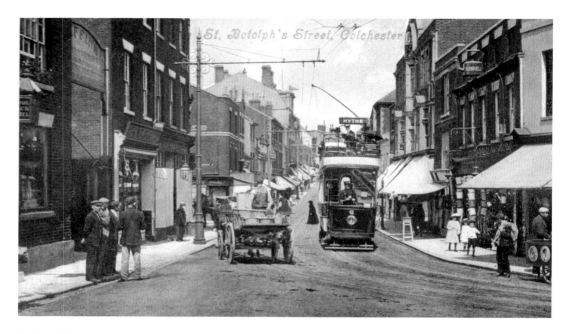

St Botolph's Street

Moving back to Plough Corner, we now look northwards up St Botolph's Street with plenty of activity in the scene above. Tram No. 6 heads towards us and a horse and cart starts the long climb up the hill towards Queen Street and the castle beyond. A group of gentlemen are having a discussion outside the Woolpack Hotel on the far left. Again, below, we have a similar view from a little further up the street. Moore & Roberts often appear in the postcards of the day, as they were producers and purveyors of postcards. Their name can also be seen on the tram, advertising their products.

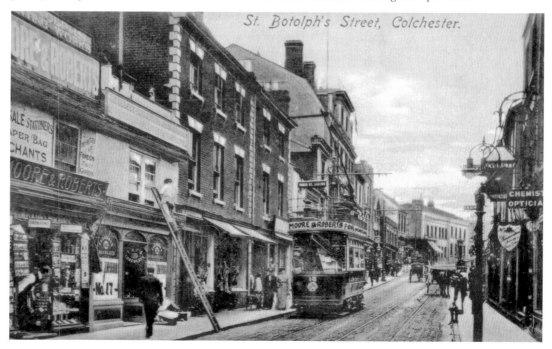

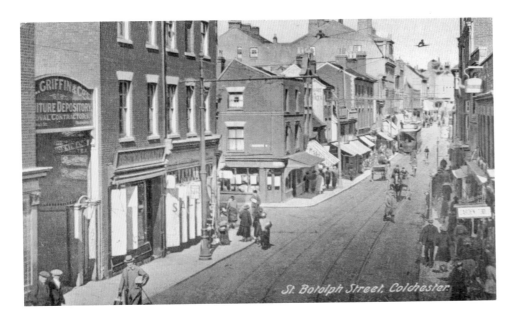

St. Botolph Street, Colchester.

Osborne Street and St Botolph's Street

The above view, looking north, shows Osborne Street off to the left. Osborne was a brewer of the early nineteenth century, and there was a large brewery premises behind the Woolpack Hotel to the left, hence the name of the road. All of these buildings on the left were swept away with the construction of Southway, as was Plough Corner, to be replaced with what is now known as St Botolph's Circus – a roundabout by any other name. The view below is of St Botolph's railway station around 1910, later to be renamed 'Colchester Town'. It was a much-needed spur off the main line at North Station, and was opened in 1866 by the Tendring Hundred Railway, a subsidiary of the Great Eastern Railway. It enabled the military to use the station for troop movements and the carrying of heavy armaments and vehicles.

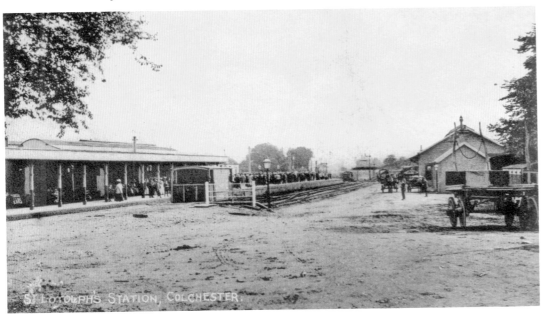

ST. BOTOLPHS STATION, COLCHESTER.

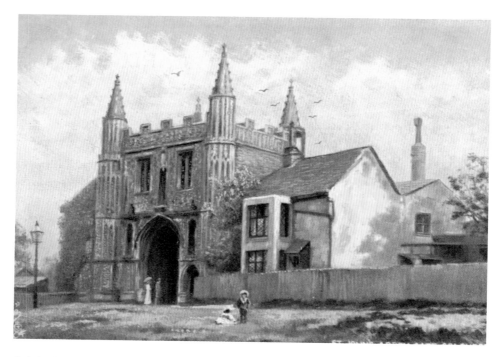

St John's Green and St John's Abbey Gate

The above picture is an 'Oilette' enhanced card and shows a delightful view of St John's abbey gate and the green in front. The Benedictine abbey of St John was constructed in the twelfth century, but succumbed to the dissolution of the monasteries in the sixteenth century, as did so many others. All that is left now is the fifteenth-century gate house, now the entrance to the private members officers' club. This was another favourite subject for the Edwardian photographer, with the general area having remained largely unchanged over the centuries. The real photographic view below takes the scene from a different angle and shows a little more of St John's Green and some children playing.

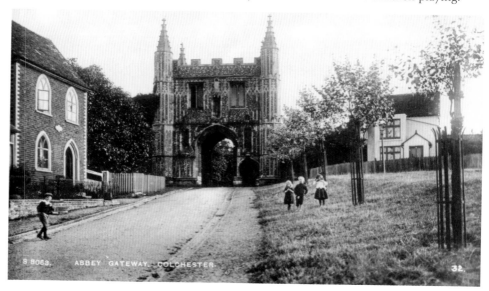

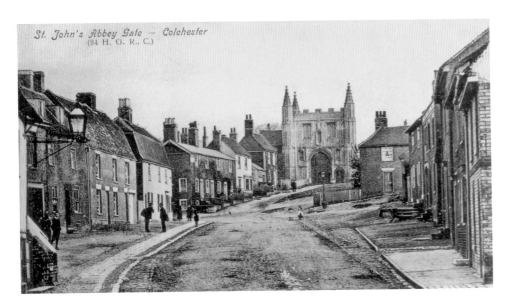

St. John's Abbey Gate — Colchester
(84 H. G. R., C.)

St John's Abbey and St Giles' Church

The picture above shows the view we had of the gate before Southway was constructed. The abbot of St John did not have a good relationship with the borough, and there was very much a 'them and us' situation. Legend tells us that things became so bad that the abbot was tricked into a meeting with the town burgesses with a view to resolving their differences. Once the abbot was on borough land, he was arrested and taken away to be hung. While there is still an abbot of St John, he never visits us anymore! Adjacent to St John's Green is St Giles' church, as seen below. Built by the abbot of St John for the people in the district, it also dates back to the twelfth century. The church was deconsecrated several years ago and is now a masonic lodge. It contains the family tomb of the Lucas family, who were given the abbey and lands by Henry VIII. This is where Sir Charles Lucas was laid to rest after his execution for being one of the leaders of the Royalists during the Siege of Colchester of 1648.

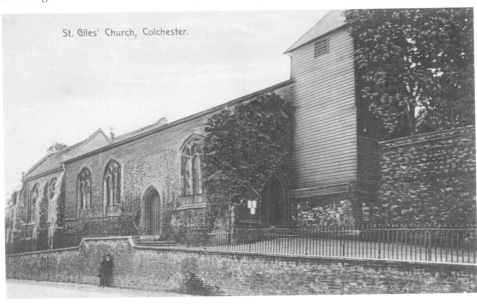

St. Giles' Church, Colchester.

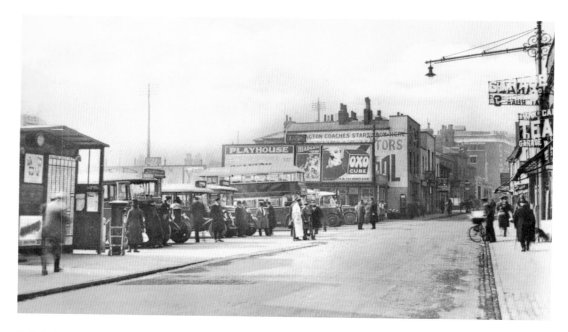

St John's Street

Nearby and to the north is St John's Street, close to the town centre. The 1920s view above shows the street looking west at a time when Colchester's bus station was located here. Scheregate Steps are to the right, but more on that later. Further along the street on the left, the Playhouse theatre can be made out. It was later to become a cinema and is now a bar. Beyond that is Headgate, and the Roman wall is on our right. The space occupied by the bus station was later to be used for a new Tesco store and car park. A similar, but later, view is shown below. Note the sign by Scheregate pointing to the NAAFI Club that was then located at the present day Arena Club on Circular Road (more on that later too).

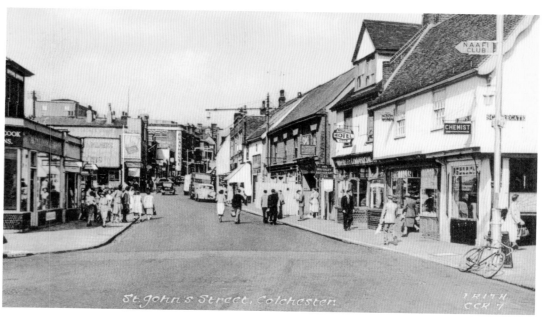

St John's Street, Colchester.

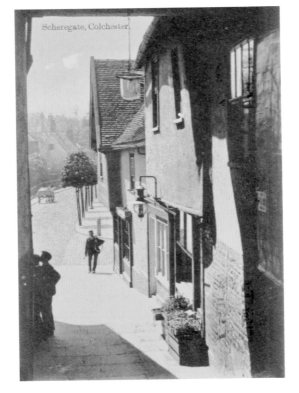

Scheregate

Scheregate, as with Balkerne Gate, is an ancient name that has been handed down to us. It refers to a small passageway that was made, breaching the Roman wall, to afford the workers access to St John's abbey to the south. Archaeologists tell us that there would have been a Roman drain here at one time, making it easier to break through, presumably in the twelfth century or thereabouts. Now, it is a picturesque little passageway with steps to raise the pedestrian the five metres or so between the Roman levels of outside the wall to the inside rampart level, along which Eld Lane and Sir Isaac's Walk follow. The above view looks in a northerly direction and the view below in the reverse direction towards St John's abbey.

45

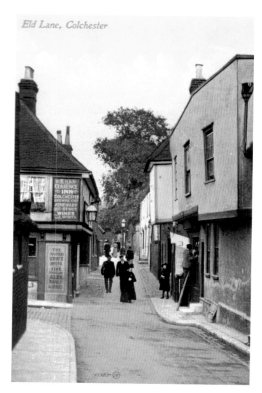

Eld Lane, Colchester

Scheregate Steps and Sir Isaac's Walk

These two views show us how things used to be at the top of Sheregate Steps and at the foot of Trinity Street. Above, we look eastwards along Eld Lane and at an old pub, then known as the Clarence, offering ales and stout from the Colchester Brewing Company. Sheregate Steps are on the right. The view below looks in the opposite direction along Sir Isaac's Walk, the Clarence pub now on the right. The Roman wall runs underneath the shops, whose cellars sometimes give an interesting view of the wall. This is one of our most ancient thoroughfares and is now lined with a range of small independent shops.

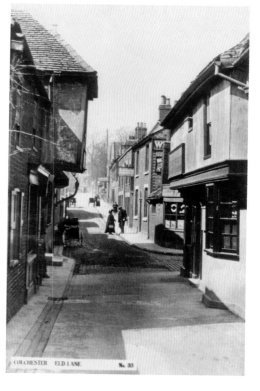

COLCHESTER ELD LANE No. 33

THE CASTLE, THE HYTHE AND LEXDEN

Colchester Castle

Colchester Castle was constructed soon after William the Conqueror became King in 1066. His marshall, or dapifer, a Norman knight called Eudo de Rie, was responsible for turning Colchester into a Norman stronghold and, in so doing, made his mark on the town forever. Realising the strategic importance of retaining the wall that the Romans had built, he made sure that it was untouched. He turned his hand to constructing his castle, St John's abbey, and who knows what else – records do not give us the details. He perhaps recognised the religious or spiritual importance of what was left of the Roman temple dedicated to the first century Roman Emperor Claudius, and so decided to build his keep, or castle, so that its walls embraced that of the temple's podium. One can only imagine what Eudo saw when he entered Colchester – a place that was once great but, by then, completely destroyed by centuries of decay. In building his keep around the podium (as opposed to on top of it), he built the largest Norman keep ever. The Roman materials he made extensive use of for his castle are in evidence today as one walks around the castle and studies the building's fabric.

The view above is how Colchester Castle looked in the 1920s, much altered since Eudo's time. Over the centuries, it fell into decay with its roof falling in and attempts were made to destroy it for the value of its materials. Thinking it was a Roman castle, its eighteenth-century owner, Charles Gray, put an Italianate roof on a part of it and introduced large, very un-Norman windows in the south face. Then, the Victorians came along and did their bit to create a beautiful park, leading to what we in Colchester now term our 'Jewel in the Crown of Colchester'. As for the little tree on the roof, legend has it that a sycamore had been growing there for many centuries. Don't believe a word of it!

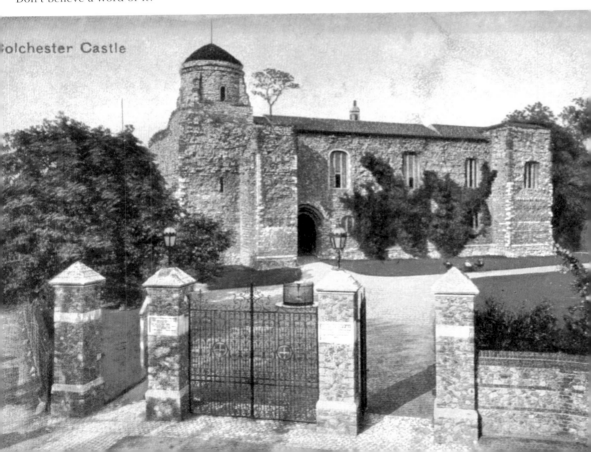

Colchester Castle

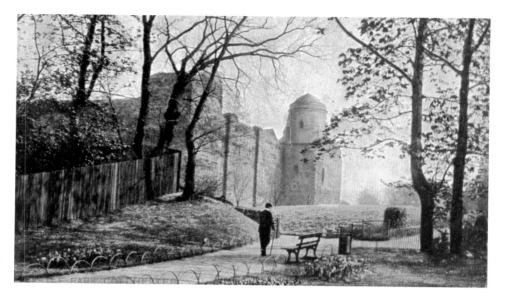

Colchester Castle

This coloured postcard shows a delightful scene looking towards the south, with Charles Gray's library standing out prominently at the top of the Great Stair of the castle. This is in stark contrast to the coldness of some the following official postcards of the castle as it was in the 1930s. The view below shows the keep without its roof, which had presumably rotted away and collapsed many years ago, or from the time when Mr Wheely bought the structure in the 1680s with the intent of reducing it to rubble and selling off the materials. In a way, he did do us a favour. His belief that there was 'treasure' hidden in the foundations led him to set about digging down, eventually discovering what turned out to be the foundations of a Roman, not Norman, building. Had he not made that discovery, would we ever have known that this was the site of the Temple of Claudius?

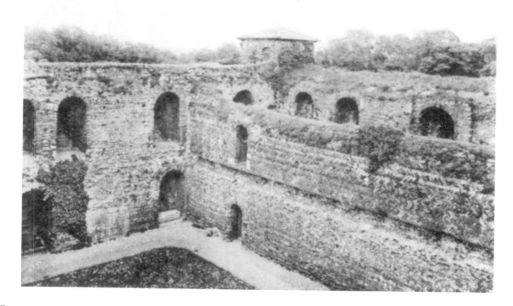

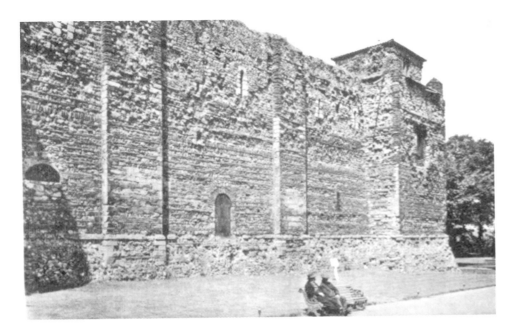

The Castle Walls

Here we see the very rough surface of the castle walls from the outside, and a few later (and very un-Norman) features of door and arched window. This is the east wall of this 'scheduled monument'. Below, we have a view of the Roman foundations, emptied out by Wheely in his quest for treasure and now part of the guided tours that are so popular with visitors to the castle. The guides will often point out the difference in the quality of the mortar used by the Romans, compared to that of the Normans. The Normans may have used part of these foundations for their *oubliettes*, a French word meaning 'forgotten'. We English coined another word for them – the dungeons, from the French word *donjon*, which simply means 'castle'.

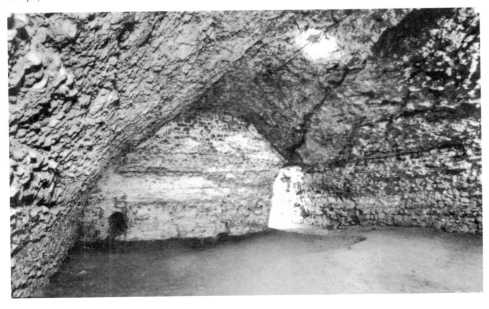

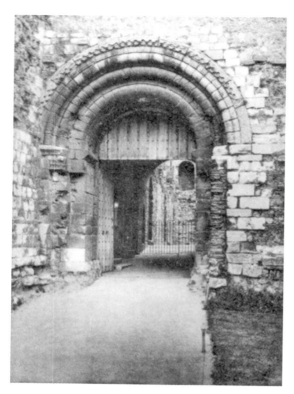

Colchester Castle

On the south side of the castle was the major doorway, as shown above right, which had a portcullis and presumably a drawbridge too, in a true Norman style. We have no clear picture of how this was arranged and there would have been outbuildings to make attack more difficult. Indeed, the south area of the castle was excavated at a later date and foundations of other earlier buildings were discovered. Rather than fill it all in again, these foundations were left exposed and today we have a modern bridge that takes us to the main entrance of the castle. Left is a picture of the door leading to the dungeons, or the borough's gaol.

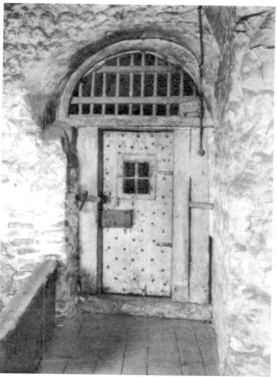

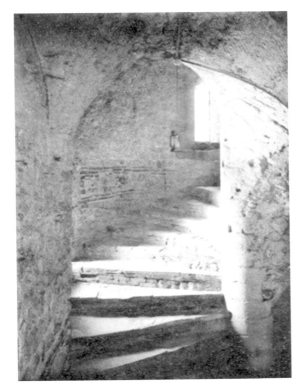

The Great Stairs

The view above is of the Great Stairs of the castle, always of interest to children when they visit. The guide demonstrates the wisdom of the Norman builders, who favoured right-handed defenders against attackers climbing the stairs. A wooden sword is kept handy to demonstrate the advantage. The view below shows the north face of the castle and its main, day to day, entrance, which is small and up high for defensive reasons. Ignore the bigger door as this was a later addition, associated with Wheely's attempted demolition.

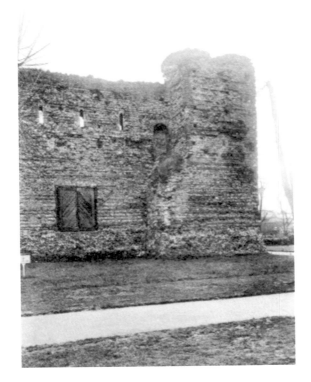

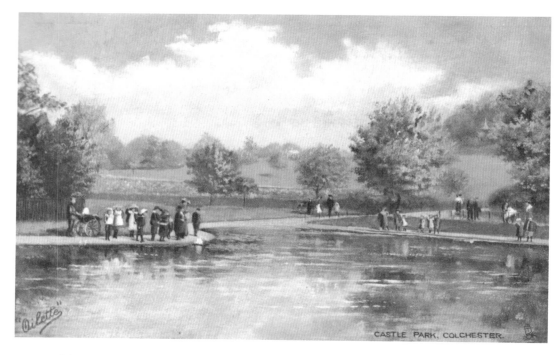

CASTLE PARK, COLCHESTER.

Colchester's Castle Park

The above picture, our second 'Oilette', shows a delightful scene from 1913 looking across in a southerly direction, at what is now our boating lake. A section of Roman wall is in the middle ground, before the steep hill that takes us up to the level of the castle and the town centre. Noticeable today is how much the trees have grown over the past century. Below, also from 1913, a group of ladies sit and talk of matters of the day while enjoying a view to the north over the Roman wall, including the lake, River Colne and Mile End in the distance.

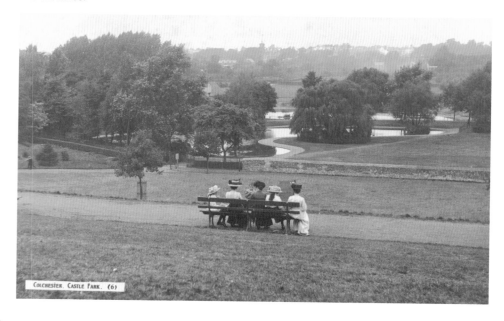

COLCHESTER. CASTLE PARK. (6)

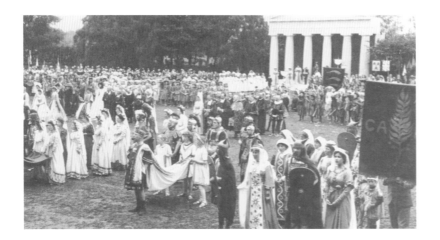

Colchester Pageant

In 1909, Colchester held a magnificent pageant to celebrate its incredible history. This was centred in the lower castle park, which is being viewed by the ladies in the card on the previous page. These cards are just two of many that were produced at that time showing part of the march and the attack by Boadicea. It was a huge event, taking us through the periods of the ancient Britons, the Roman invasion, Boadicea's attack, Edward the Elder, Queen Elizabeth I and the Siege of Colchester. We are unlikely to see the like of this again.

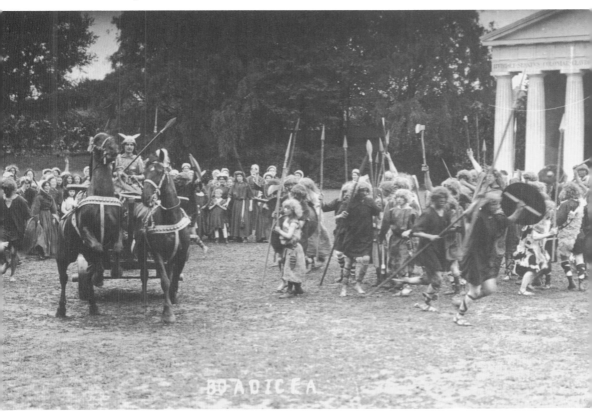

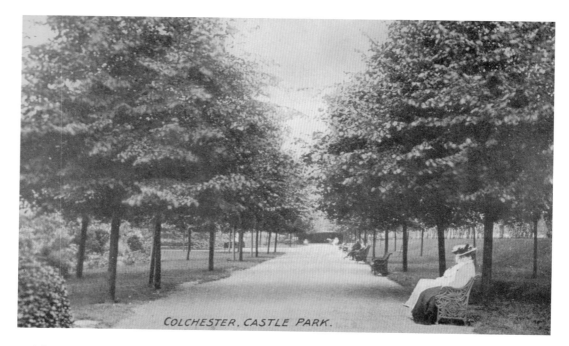

COLCHESTER, CASTLE PARK.

Colchester Castle Park

Here we have two more cards showing just why the park was so popular. It is difficult to imagine just how this area would have looked during the Roman period, as the colonia was full of buildings and this pleasant area would have been a bustling scene of Roman life. Over the centuries, land was acquired and the park was developed. Today, we have a wonderful park that is much loved by residents and visitors alike. The trees, shrubs, flowers and fauna have been carefully selected and managed by the borough's gardeners to make this a prize winning park. In particular, our Avignon and Wetzlar Gardens (named after two of our twin towns) are a wonder to behold during spring and summer months.

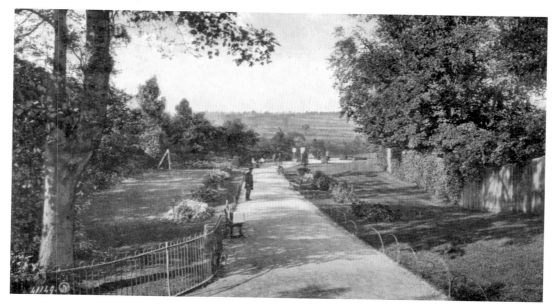

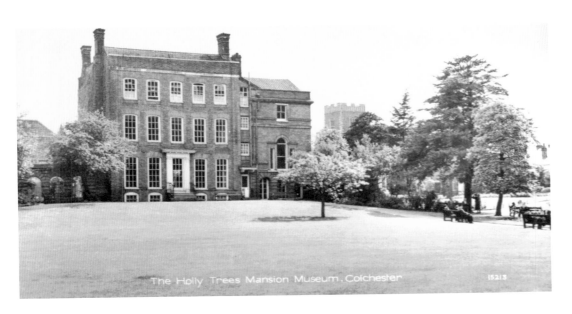

The Holly Trees Mansion Museum, Colchester 15213

Castle Grounds

Within the castle grounds we have Hollytrees Mansion, once the home of Charles Gray, who was given the castle as a wedding present. He made many improvements to the castle's park before it was eventually sold to the borough in later years. Today, this building houses our Visitor Information Centre and a museum. The view looks south, with All Saints church in the background. Turning to the right, you get this view of the magnificent castle's east side. Its huge apsidal end, indicating its Christian significance, faces east and therefore Jerusalem. The experts are divided as to how tall the castle was. It was certainly built higher, in stages, as the building materials show later-infilled castellations. It is generally thought that this was close to its original height, despite the destruction wreaked by Wheely.

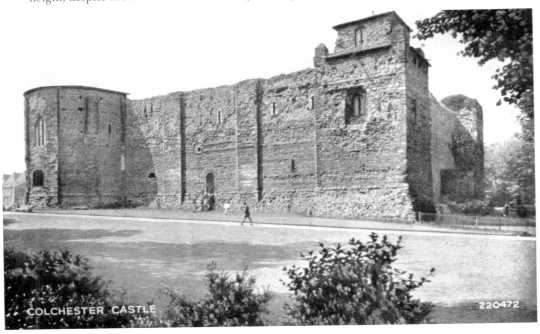

COLCHESTER CASTLE 220472

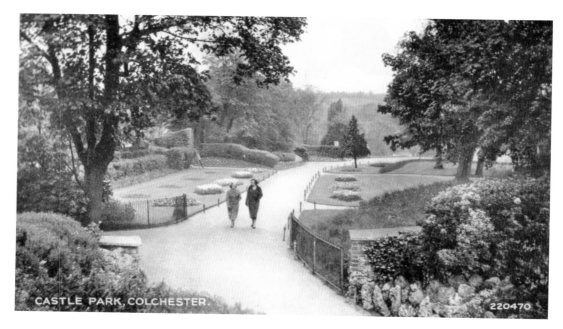

CASTLE PARK, COLCHESTER. 220470

Castle Park and Boating Lake

In the view above, we have the remains of the Norman's northern bailey (an earth mound thrown up to give better defence against attack). As the Victorians expanded the gardens, they discovered, beneath the bailey, one of the Roman temple precinct walls, as can just be seen to the right and left of the pathway in the foreground. While they cut a way through it for the necessity of providing a path, they left the wall sections exposed. Before we leave the park, the view below takes us back to the Lower Castle Park, to the boating lake, still very popular with children when they visit. Today ,this area of the town is used extensively for the staging of shows, concerts and fairs, in continuance of the leisure tradition. What would the Romans have made of it all?

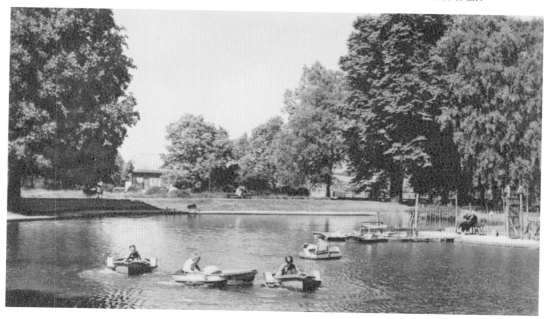

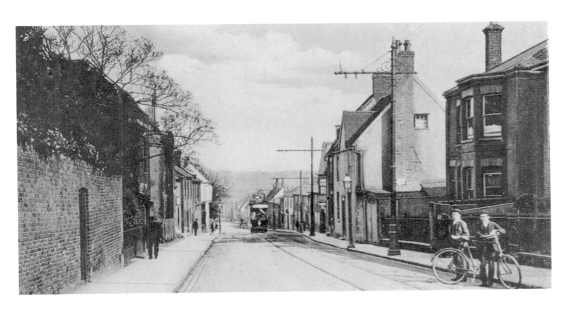

Hythe Hill

There are many places across the country named the Hythe. It was the port of Colchester for many years, undoubtedly dating back to its pre-Roman use as a port and haven. As we make our way down to the Hythe, we leave the town centre, travelling along the much unrecorded Magdalen Street and Barrack Street, where the third of our four medieval churches once stood outside the walls of Colchester. It was the church of St Mary Magdalen, demolished in the 1980s to make way for new housing. It was also the site of a medieval leper hospital. The church and graveyard were destroyed, and bodies dug up and swept away, just for a few flats. We soon reach Hythe Hill, as can be seen in the view above. According to recent legend, 'you couldn't have a half pint of beer in every pub on the straight line between St Botolph's and the Hythe and still remain standing.' There were twenty-four pubs at one point, so some of the 'good old boys' of the town, no doubt, would have tried it. A tram is making its way down the otherwise traffic-free road. Towards the foot of the hill, we have the last of our four medieval churches outside the walls, that of St Leonard's, as seen in the card view above.

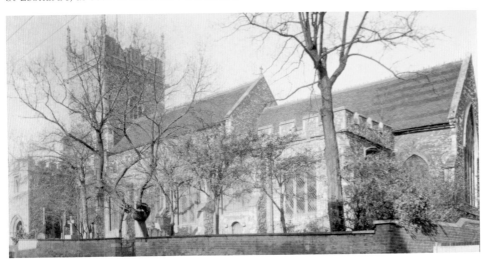

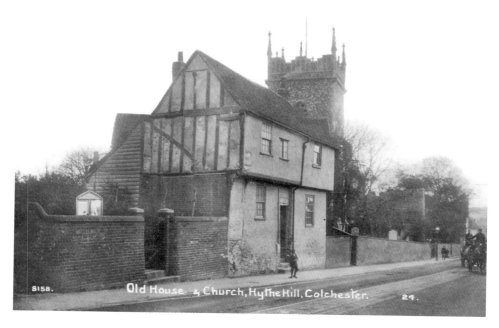

Hythe Hill

The view above shows one of the many timber-framed houses from the medieval period that still exist on Hythe Hill. Indeed, some of the oldest houses in Colchester are at the foot of this hill, a record of the wealth of some of the people that once lived here. This card was posted in 1914 and gives us an easterly view of St Leonard's church and the entrance to a small chapel that once stood there on the left. The view below shows a delightful scene of old houses and the church, together with the Dolphin public house, then owned by another of our local brewers, Daniell & Sons, whose main brewery was in West Bergholt. The sign of the dolphin is a reflection of the seafaring propensities of it likely customers from the dock area only a few yards away.

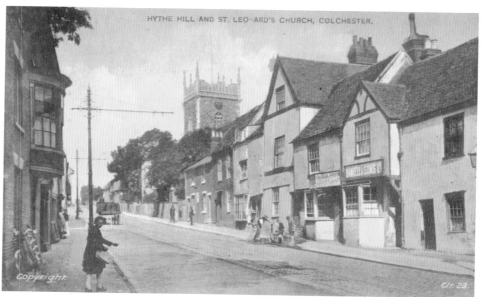

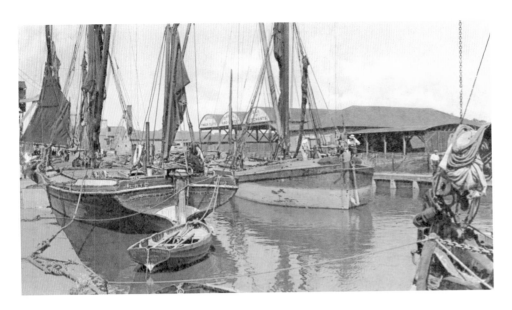

Hythe Quay

Now we come to the docks and a selection of Thames barges moored up and waiting to be loaded or unloaded, or for a favourable tide (the River Colne is tidal in this part). The above postcard is dated 1946 and the boat on the right bears the name *Paglesham*, a 55-ton sailing barge built in 1877. The original owner's business was with flour mills, but at the time of this picture her future working life was short. She was sunk by a steamer in 1947, raised, but condemned, and acquired by the Sea Scouts. *Imperial* is on the left in the picture, but space limits more detailed information about her. In the lower picture, we get another view of Groom Daniels' woodyard. The nearest barge is the 'gem' of Colchester, weighing 100 tons and originally a coal-fired sailing steamer built of iron in South Shields in 1881. The card is dated 1913 and the view looks west.

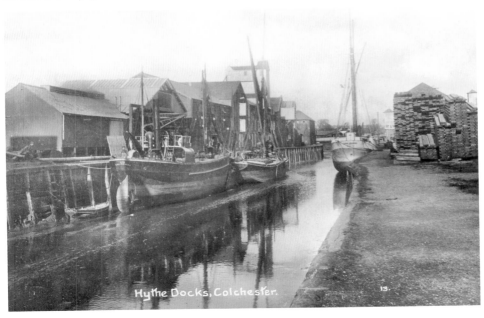

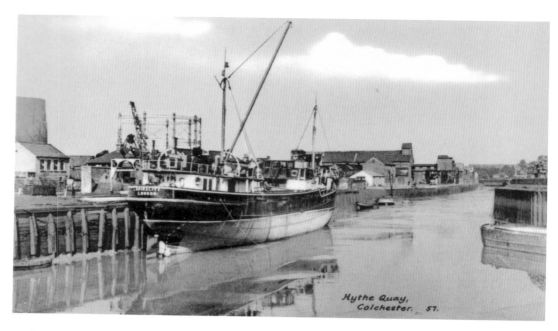

Hythe Quay

The above view, looking west, shows the *Spirality* of London moored at low tide and stuck fast until the tide comes back in again. In the background we have a gasometer, associated with Colchester gasworks at the Hythe. On the right of the picture is the edge of the winding point, a wide section where boats were able to turn around in the channel. Below, we have a similar view but from an earlier time. This card was posted in 1906 and shows us many of the wooden Thames barges moored up. Numerous warehouses, public houses and service buildings line the dockside. The prominent Parry's Oil Mills, standing out, was one of the major businesses at the Hythe at that time. A chap with a flat cap looks on, adding to the charm of the picture.

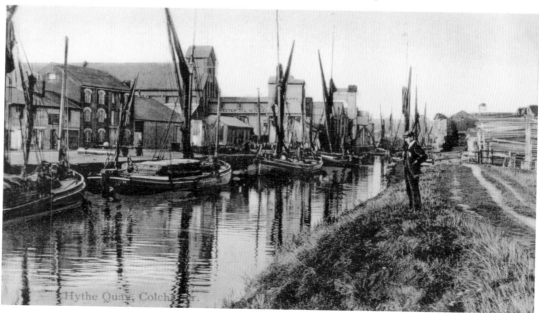

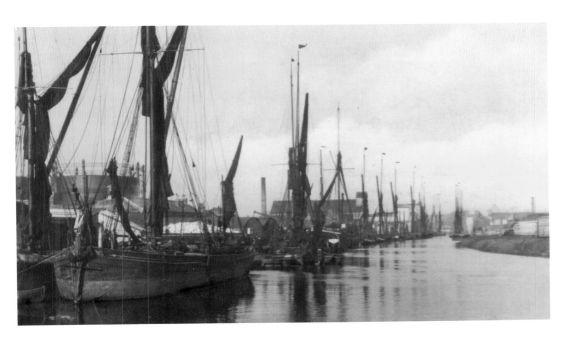

Hythe Quay

How many masts can you count in the above view? Posted in 1931, the first boat has the name 'Centaur' and was 'of Rochester'. The card below was posted in 1930 and shows us the area of docks that was associated with the gasworks, coal yards, maltings, etc. While we cannot name the vessels, the first one appears to be carrying a good load of beer barrels, either the product of one of our local breweries being sent away, or perhaps from one of the London or Ipswich brewers (Truman, Hanbury & Buxton of London or perhaps Tollemache of Ipswich), who owned pubs in the town. The tide is rising and the boats will be on their way. The river, as any other tidal river, was prone to silting-up and regular dredging was necessary to maintain the depth of water. Sailing such a vessel down a long and winding river, could not have been an easy matter.

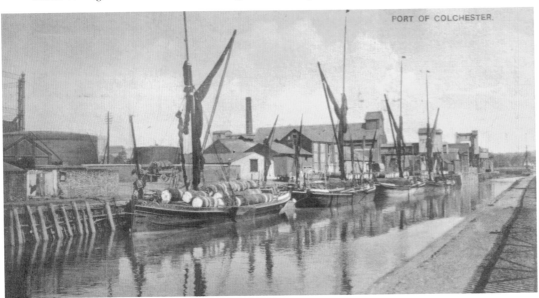

PORT OF COLCHESTER.

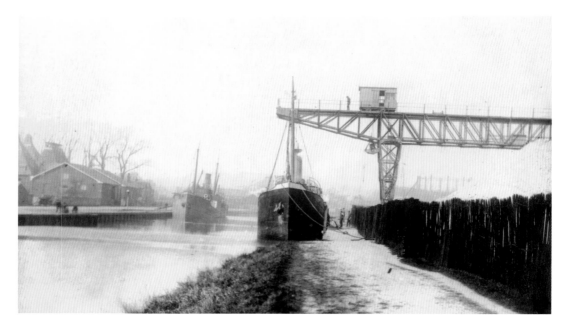

Hythe Quay

The Moler brickworks at the Hythe imported clay from overseas and converted it into a special type of brick. The picture above, a west-looking view, dates from 1921 and shows their Vickers crane employed with loading and unloading the ships. On the left we can see the interestingly shaped roofs of the maltings, so dependent on the docks for bringing in the barley to be malted and sent on to the various brewers in the town and elsewhere. Most of us who were around in those times will remember the smell of the malt, as well as that of timber, fishmeal, and the other produce and materials that passed through the docks, not to mention the smell from the nearby sewage treatment works! The view below is another gem.

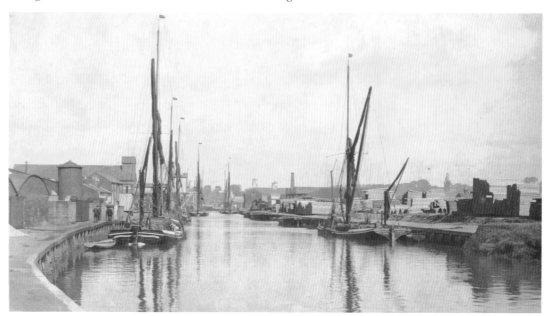

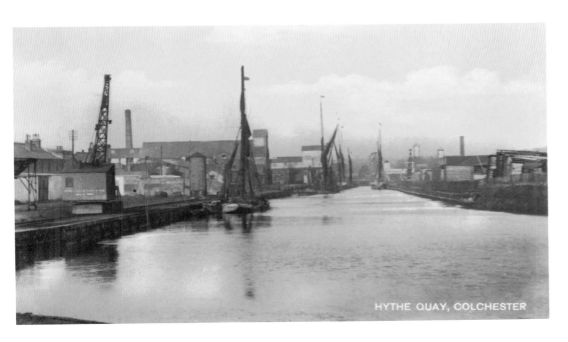

HYTHE QUAY, COLCHESTER

Hythe Quay

The card above dates from 1931 and gives us a view, on the left-hand side, of the mobile dockyard crane along what was named King Edward Quay. Moler's crane is in the distance, with the printing works of Spottiswoode Ballantyne on the right-hand side. The docks were closed in the 1990s due to redundancy. Container traffic had taken over at places like Felixstowe and Tilbury, and Colchester simply could not compete. Now, the docks are being developed for a more leisurely purpose, with talk of a half-tide barrier to create a marina for houseboats. So, we leave the Hythe with the advertising postcard below, produced in 1908 by Owen Parry Ltd Oil Mills, giving price details of their linseed and cotton cakes on the reverse side.

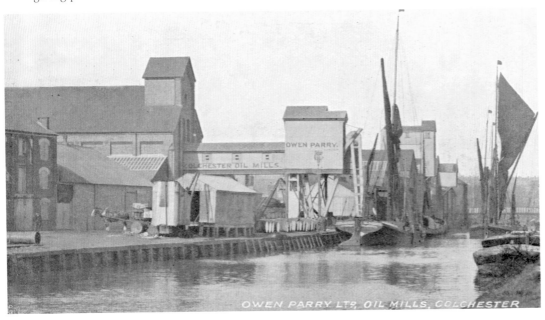

OWEN PARRY LTD. OIL MILLS, COLCHESTER

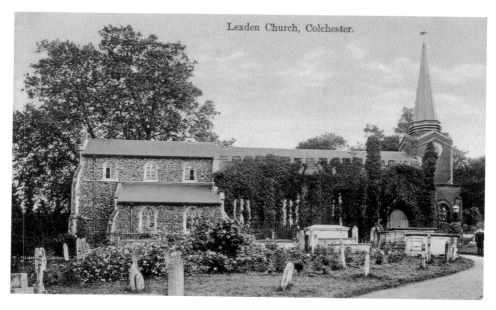

Lexden Church, Colchester.

Lexden

When approaching Lexden, we can do no better than start with its lovely church of St Leonard's. This card is dated 1930, and shows the interesting range of architectural features. Lexden is now a suburb of Colchester, considered by some to be at the 'classier' end of town. It was formerly a village, located on the main Roman road that led to London and the oldest part on a section of lowland close to the River Colne and flanked by the remarkable Iron Age earthworks that pre-date the Romans. With the development of housing during the Victorian period, Lexden Road now gives a continuous connection with the main town of Colchester. The view below looks westwards along Lexden Road as the road drops down into the village.

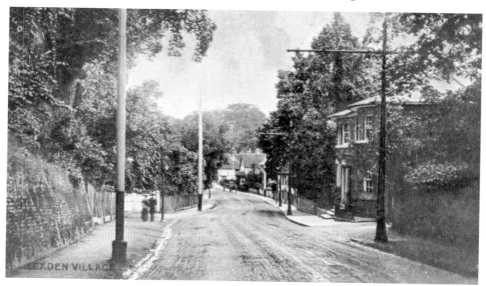

LEXDEN VILLAGE

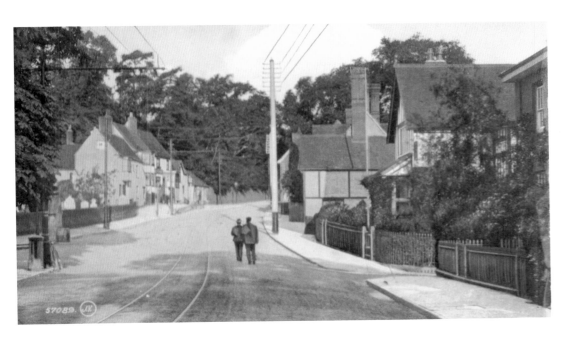

Lexden

Following on from the previous card, we reach the village proper, with the church just out of sight on the left and the ancient Sun Inn further along on the left. Immediately to our left, in the above picture, is Lexden Park, which we see from a different direction in the view below. Later to become a college annexe to Colchester Institute at Sheepen, it was sold in the 1990s for conversion into residential apartments. Parts of the park are open to the public and the Iron Age earthworks, known as Bluebottle Grove, can be explored in the area to the right of the picture.

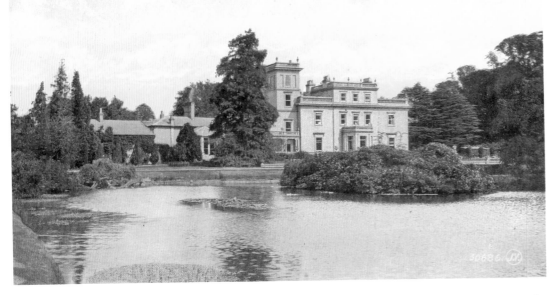

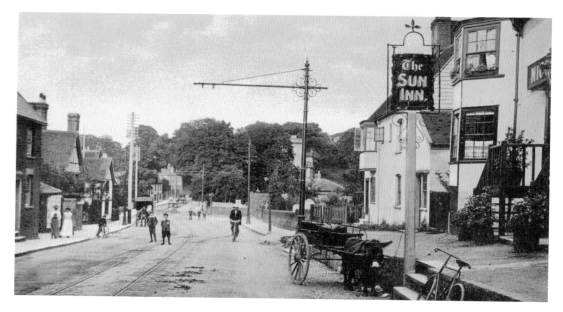

Lexden

The Sun Inn dates back many centuries, it being one of the many medieval period timber-framed buildings that are so common in this part of the country. Unlike the north and west of the country, Essex has no natural building stone, but it did have plenty of trees from which to either build ships for the navy or houses. No doubt the owner of the donkey and cart was inside the hostelry, 'wetting his whistle' when this picture was taken. The tram system came all the way out here, as can be seen by the rails in the road. This view looks back towards the town. Looking across the road, we have another view below showing more of the old houses, with Spring Lane off to the left. As the name suggests, there are natural springs here, and the River Colne, where a mill once stood. The card is dated 1905.

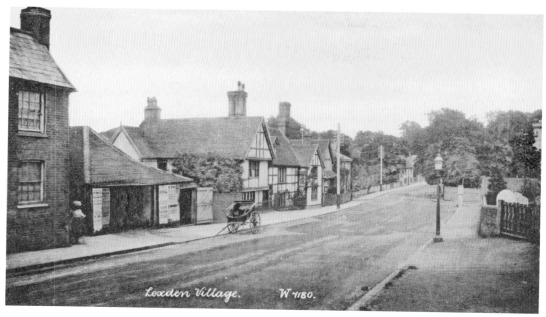

Lexden Village. W 4180.

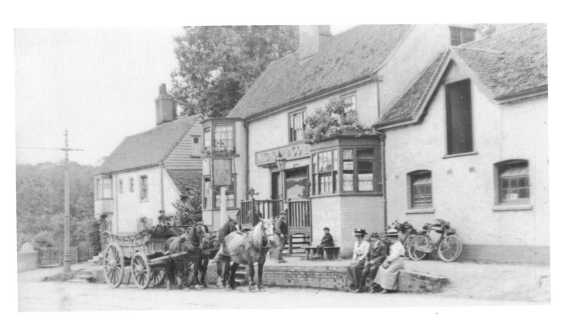

Lexden

The image above, of photographic perfection, shows a delightful scene of a bygone age. Here we have it all: a heavy cart pulled by three horses, ladies and gentlemen with their bicycles and the sign of Nicholl & Co. Ltd at the Sun Inn. Today, the pub has been lost to private use and the road is packed nose to tail with parked cars. The view below is a view that shows a cluster of houses further to the north, along Spring Lane. This village was cut in two by the construction of the A12 dual carriageway in the 1930s, and the lane pops out the other side of a huge modern roundabout to a road that is now known as Baker's Lane. Here we have the river and Lexden Bridge, with a cluster of old houses that were probably much associated with the mill that once stood here. The river flow isn't great here most of the time, and the picture shows that it could easily be forded at that time.

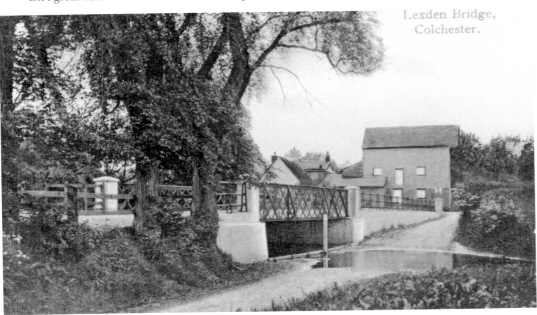

Lexden Bridge,
Colchester.

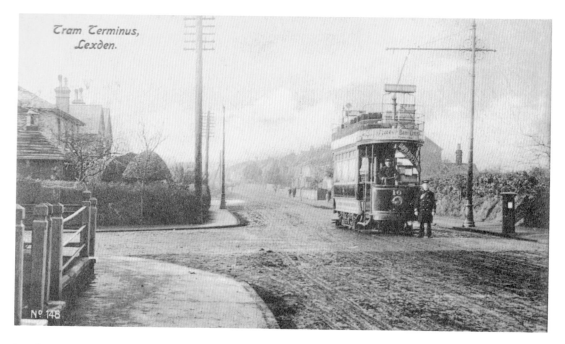

Lexden

The view above shows us the end of the line for the tram, where the driver would have had to change ends and the tram would have headed off back into town. This view is looking west, with London Road and Stanway going off into the distance towards London. The view below dates from the 1930s and shows Kingsland church at the top of the hill, before we enter Stanway. Here we are looking east, back along Lexden Road and towards the town.

THE GARRISON

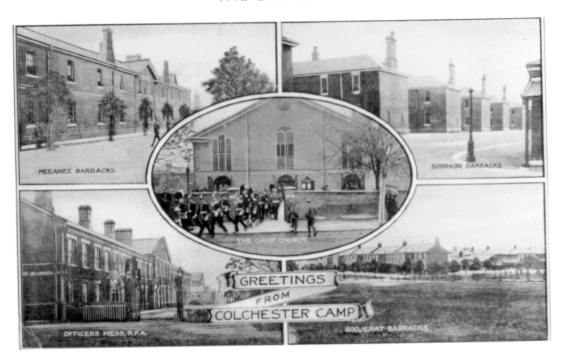

MEEANEE BARRACKS.

SOBRAON BARRACKS.

THE CAMP CHURCH.

GREETINGS FROM COLCHESTER CAMP

OFFICERS MESS, R.F.A.

GOOJERAT BARRACKS.

Colchester Barracks

In the year AD 43, the Emperor Tiberius Claudius Caesar Augustus Germanicus (commonly known as Claudius) and his Roman army invaded Britannia. he made an immediate path to a place called *Camulodunum*, the location of the most powerful tribe in Britain. Here, he took the surrender of eleven British chiefs and began his attempt to conquer these isles. In doing so, he built forts and barracks here, giving Colchester the oldest known garrison. As we all know, the Romans left town around AD 410 and it wasn't until many centuries later that Colchester developed its garrison once again. Although the restoration of the Stuart Kings over 300 years ago gave birth to the standing army, it was not until the outbreak of the Anglo-French War in 1793 that barracks were built in Colchester and other towns up and down the country. The pressing needs of the day made for prompt action and, by the time the Peace of Amiens was signed in March 1802, wooden hutments for 5,840 men had been erected. Additions were made from time to time but, following Waterloo, the garrison at Colchester was speedily reduced and hutments and other buildings were sold and removed. By 1827, the establishment was closed, with a serious effect on the prosperity of the town for some years.

Then came the Crimean War, which revived the military traditions of Colchester, and a new camp was opened in February 1856. This consisted of wooden huts on brick foundations occupying the Ordnance Field of the Napoleonic period (at the top of Military Road, as we know it today). These were replaced by brick buildings in 1898, and named 'Meeanee' and 'Hyderabad', only to be rebuilt during the 1950s.

So, with this proud heritage behind us, the following series of postcards shows scenes that most Colchester people would, until recently, have been quite unfamiliar with. This is because, in 2004, the land on which these barracks stood was sold for development, with a new and modern Merville Barracks built for our modern army. From then on, the general public came to discover what lay behind the tall walls and barbed wire fences, so necessary in previous times for the high security that was attached to army activities.

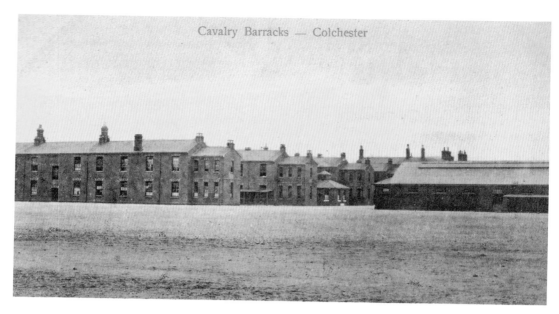

Cavalry Barracks — Colchester

The Barracks

It is difficult to present these cards in any structured order, as the garrison grew in several different areas at a similar period in time. So we start with a look at the area of Colchester's barracks where the oldest surviving buildings are. The first of the permanent brick buildings were at Cavalry Barracks (off Butt Road), whose buildings were constructed from 1862. Some of the barrack blocks shown in the above picture still exist, although this area is now (2014) in the process of having housing built on the old parade ground and the historic buildings being converted for housing. The view below is of the 16th Lancers changing guard at the entrance to Cavalry Barracks and this building (the Guard House) has been preserved for posterity.

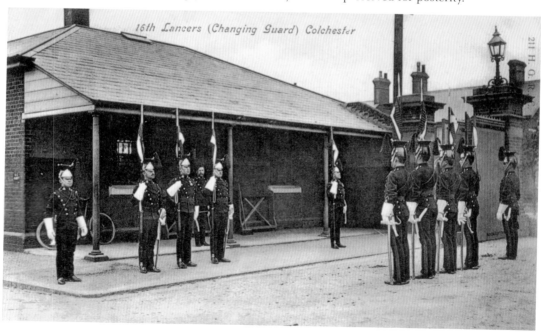

16th Lancers (Changing Guard) Colchester

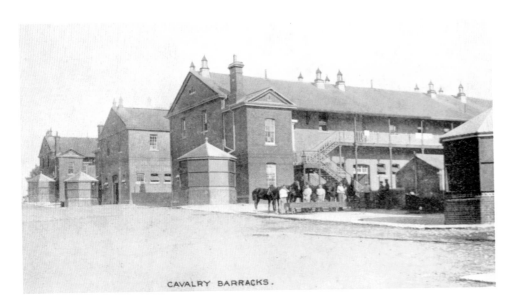

CAVALRY BARRACKS.

Cavalry and Artillery Barracks

Sadly, the buildings in the view above have been lost to us. As the name suggests, the Cavalry Barracks were connected with the cavalry (from the French *cavalerie* and *cheval* – horse), also variously known as horsemen or troopers. At this time, the cavalry was the most mobile of the combat arms and historically the third oldest after infantry and chariotry. The stable blocks were laid out in such a way that the horses were kept at ground level and the soldiers quarters above, the theory being that this was good for the bonding of soldier and horse. To the north of Cavalry Barracks, was the Artillery Barracks. The card below shows the officers' mess of the Artillery Barracks, built in the 1870s. In 2005, it was realised that the eight starting gates of the only Roman circus in Britain were perfectly located in the gardens of this building – whether by design or coincidence, we will never know.

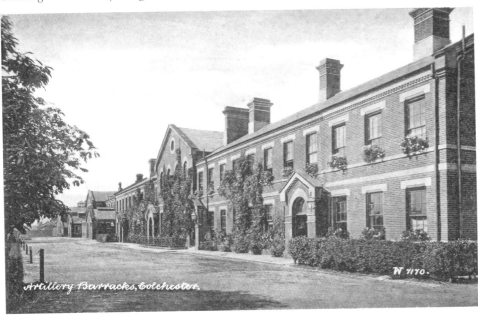

Artillery Barracks, Colchester.

W 7170.

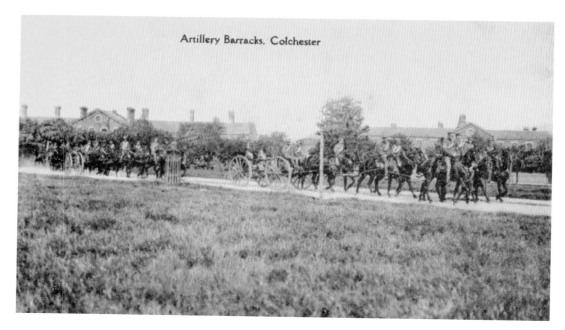

Artillery Barracks, Colchester

Artillery and Goojerat Barracks

The above card shows artillery soldiers with their horses, pulling guns along the road, with the Artillery Barracks in the background. This view looks north-west. The artillery was the branch of the army that specialised in the use of large calibre weapons, such as cannons and howitzers, as opposed to hand-held weapons. Further to the south, the Goojerat Barracks were built, as can be seen in the card below. Close to them were the barracks of Kirkee and McMunn. Most, if not all of these buildingsv have been swept away, to be replaced with more modern quarters for military families, or for the land to be sold to developers for civilian use.

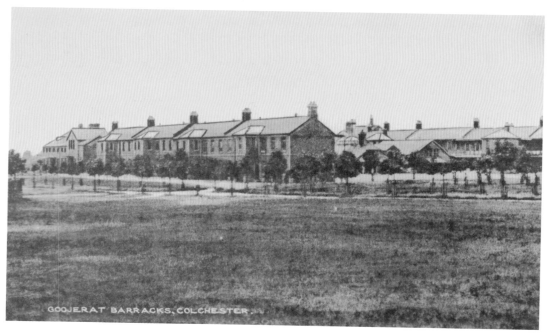

GOOJERAT BARRACKS, COLCHESTER

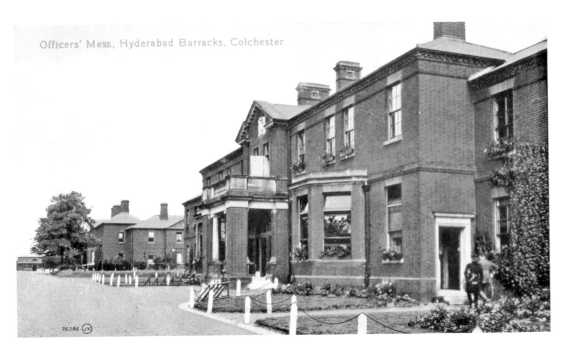

Officers' Mess, Hyderabad Barracks, Colchester

Hyderabad Barracks

To the east of the military garrison lands, on the east side of Mersea Road (as we know it today), we have what is left of the Hyderabad and Meeanee Barracks. The above card dates from 1916 and shows the officers' mess of the Hyderabad Barracks, a building that has survived and been converted for civilian use. These buildings were of the 1890s period, replacing the wooden hut barracks of the Crimean War period (1853–56). The card below gives a wider view of the parade ground and dates from 1918. Of course, these views were taken at the height of the First World War. Again, many of these buildings have gone now, especially those on the left of the picture.

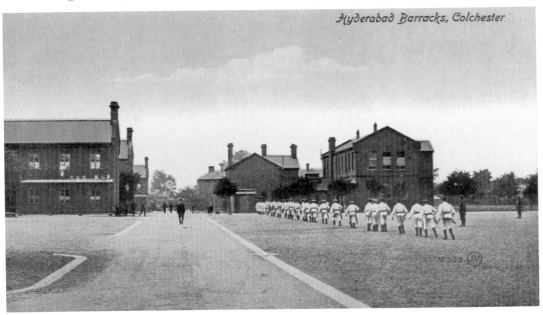

Hyderabad Barracks, Colchester

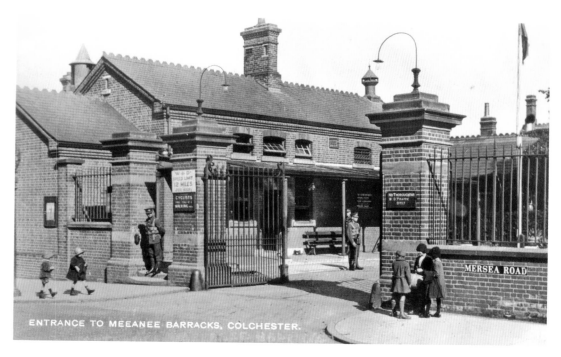

ENTRANCE TO MEEANEE BARRACKS, COLCHESTER.

Meeanee Barracks

To the north of Hyderabad Barracks were the Meeanee Barracks, the main gate of which, along Mersea Road, is shown in the above picture. The gate is still there, as are some of the buildings, but the whole site is now covered with new housing. Below, we have a view dating from 1906 of the several blocks of these barracks. Serving soldiers would send these cards to their loved ones to gives news of how they were getting along and when they expected some home leave. These buildings below are now all gone.

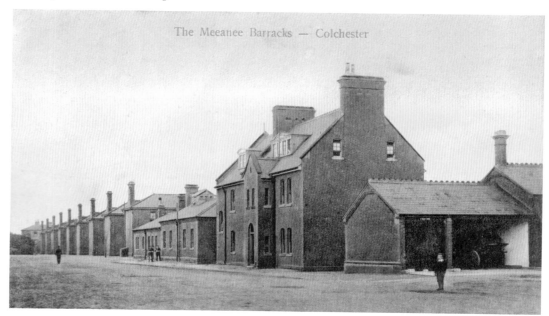

The Meeanee Barracks — Colchester

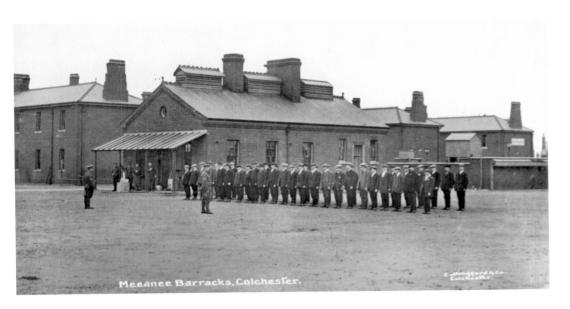

Meeanee Barracks, Colchester.

On Parade

The above card, dated November 1914, says it all. A group of men in civilian clothing are lined up and, one assumes, are being inducted into the ways of the army. How many of them survived? The view shows more of the military buildings that are lost to us now. These were infantry barracks and most of the men would have been sent across to France to fight the 'Bosh', a term of abuse used by our men in the trenches in reference to the German army. The picture below gives us a view of a body of soldiers all lined up on parade on the Abbey Field, with military tents in the mid ground and the barracks in the distance. There were not comfy barracks for everybody and some had to be accommodated under canvas in times of need.

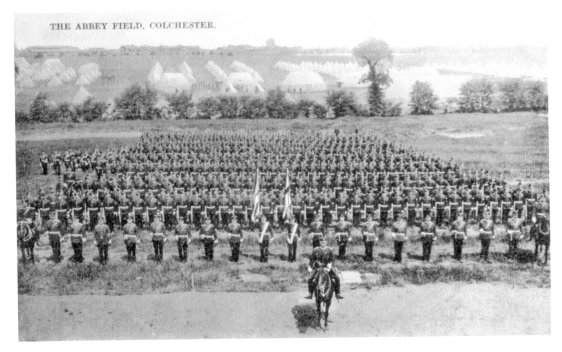

THE ABBEY FIELD, COLCHESTER.

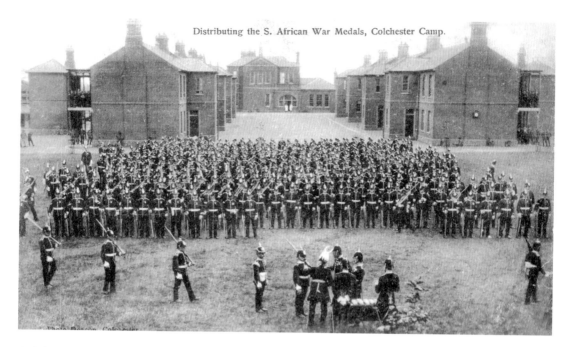

Distributing the S. African War Medals, Colchester Camp.

Colchester Barracks

The above picture shows soldiers assembled on the camp's parade ground and being presented with their South Africa Medals in June 1903. Barrack buildings are in the background. These men, who are receiving the King's Medal from General Buchanan CB, are believed to be from the Norfolk Regiment. In the picture below we have a similar scene, although with members of the public in attendance. This area was originally the site of the wooden hutments that were constructed in the 1850s and later occupied by Hyderabad and Meeanee Barracks.

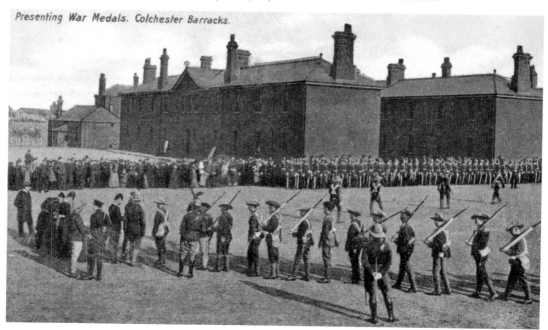

Presenting War Medals. Colchester Barracks.

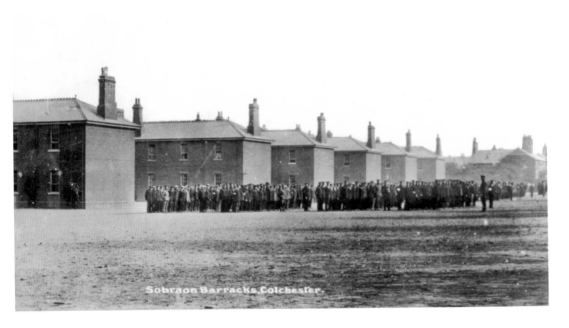

Sobraon Barracks, Colchester.

Sobraon Barracks

Further to the south of the garrison land lay the Sobraon Barracks, most of which have now gone. Some interesting remnants remain, which have been converted for civilian use and land for new housing. These two cards give us views of how the barracks were laid out. The card above had a note from son to mother, stating that he had failed for infantry but had passed for the Army Veterinary Corps, 'getting $3d$ a day in England and $4d$ a day abroad'. There is a plan of the barracks' locations in the map section of this book.

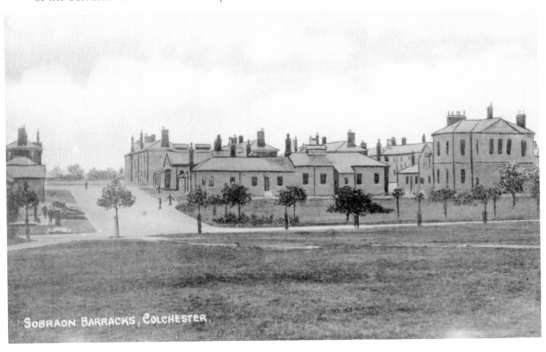

Sobraon Barracks, Colchester.

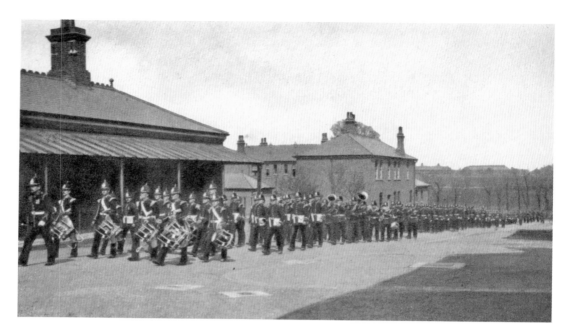

Military Bands

Military bands were very important to the army way of life and many postcards recorded this. The above card is another from the Sobraon Barracks. Below, we have the band of the East Lancashire Regiment on Church Parade, with some of the barrack blocks in view. For many years, Colchester held its Military Tattoo either in Castle Park or on the Abbey Fields, something for which Colchester people have fond memories but is sadly now a thing of the past in this cost-cutting age. A combination of terrorist threats, an actual bombing that maimed a soldier and the cost of staging these events, led to its demise.

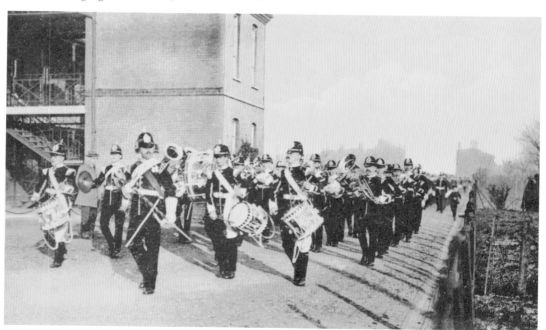

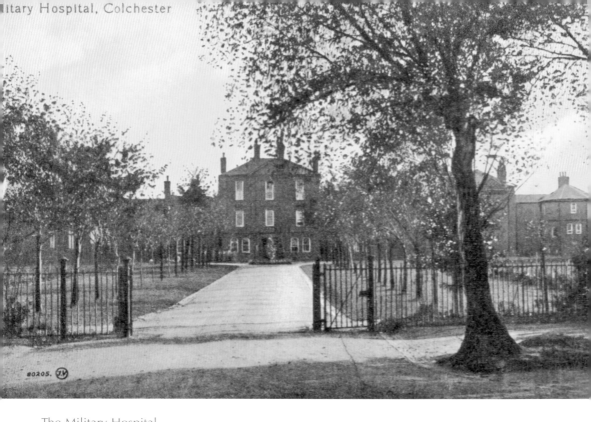

80205.

The Military Hospital
An essential part of army life was the hospital. These two views show us the military hospital that was built in 1896, closed in 1977 and demolished soon afterwards. Casualties would have been brought here from the First World War, as well as military personnel requiring medical treatment. In the 1950s, it was opened up to civilians and was said to have offered an excellent standard of care.

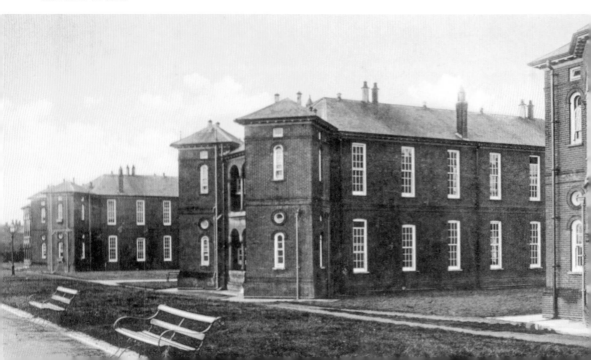

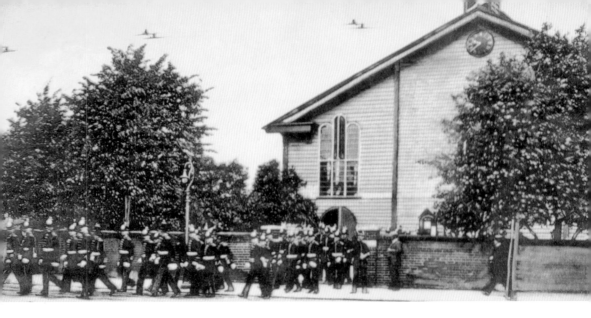

The Camp Church

Another important part of army life was the church. These two views show the Camp church, as it was known. The above view dates from 1909. The church dates from 1856 and is the largest timber building in England. It was made to a similar design as the wooden hospitals that were sent out to the Crimea for use by Florence Nightingale on the battlefront. It was made redundant in 2007 and is now used by the Russian Orthodox Church in Colchester. It was built on a much earlier, Napoleonic era graveyard plot, with some gravestones of that period still in existence. Importantly, the church parade provided an opportunity for the public to see 'their' soldiers on parade in all their splendour. The gates to the camp were on the opposite side of the road.

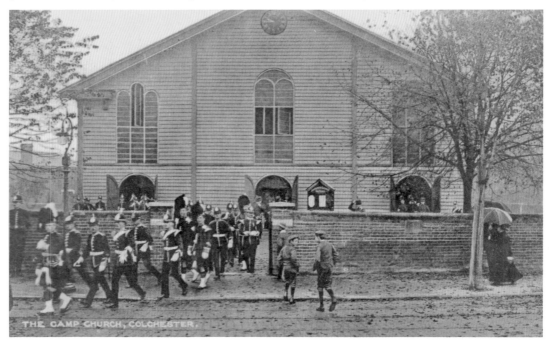

THE CAMP CHURCH, COLCHESTER.

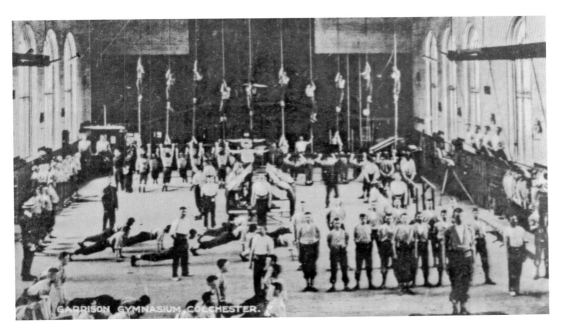

GARRISON GYMNASIUM, COLCHESTER.

Fitness and Recreation

Two other aspects of army life were the gymnasium and relaxation. The picture above shows the inside of the Victorian period gym, the building being near to the military hospital and sadly extensively damaged by fire in 2013. Colcestrians have been used to the sight of soldiers on route marches for many years – all part of the training! Below, we have a postcard dating from 1947. The Navy, Army and Air Force Institutes (NAAFI) was an organisation created by the British government in 1921. It ran recreational establishments required by the British Armed Forces and sold goods to servicemen and their families. This particular one was located at what we now know as the Arena Leisure Club.

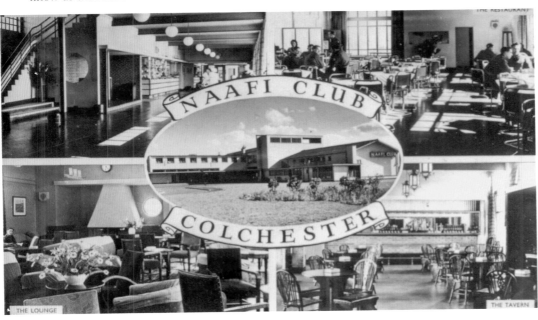

NAAFI CLUB COLCHESTER

THE LOUNGE

THE TAVERN

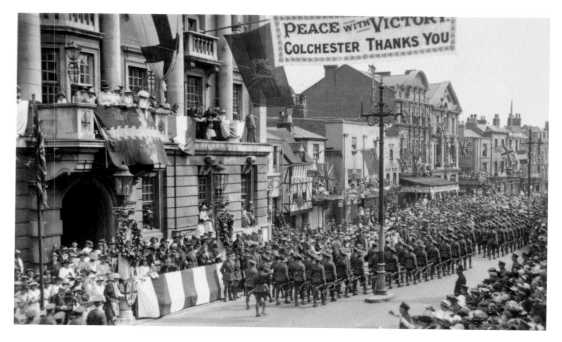

Victory March

Many postcards recorded the end of the First World War and here we have two examples from Colchester. Members of the armed forces marched through the town in 1919 and received the thanks of the people for the 'Peace with Victory'. Nearly 1,300 of Colchester's sons were killed or lost in action. The above view shows the High Street, with our civic dignitaries in attendance outside the town hall, while the street is packed with members of the public as the soldiers march by. Below, we have a similar scene in Queen Street with members of the Essex Regiment (the Pompadours) coming through.

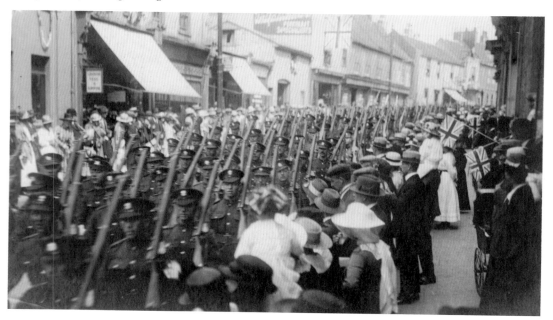

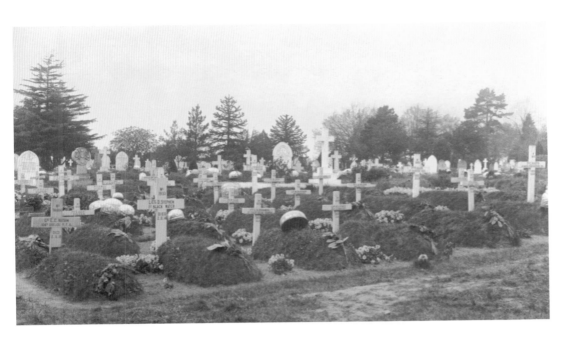

Colchester Remembers

On Mersea Road we have Colchester Cemetery, where a special area is set aside for military burials. The picture above dates from 1919 and shows the temporary crosses set up before the Commonwealth War Graves Commission developed the current system of identification of war graves. These casualties, who must have been brought back from France and Belgium during hostilities, and after they had ceased, succumbed to their injuries. Our magnificent war memorial, honouring the dead of 'the war to end all wars', was erected soon after. The picture below, of a tradition that the town still follows strongly each Remembrance Sunday, tells it all.

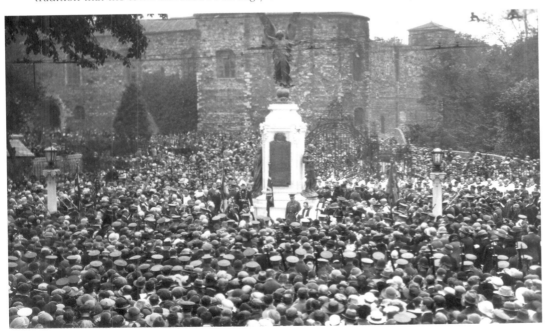

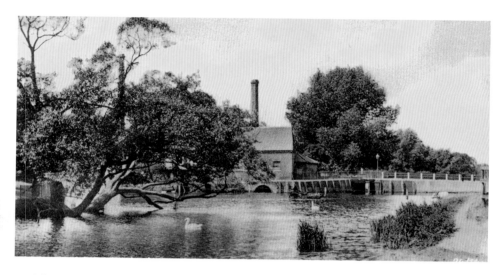

Middle Mill and Bourne Mill

Middle Mill was one of several water-powered mills in Colchester, all dating from medieval and earlier periods. They were used for the age-old process of corn grinding, or for fulling (associated with the town's lucrative cloth trade). This corn mill, which was also used for the fulling of cloth, was located on the River Colne near Ryegate and is recorded in the early twelfth century. It was later bought by the owner of the castle, Charles Gray, in 1757. In 1933, the millers sold out to Marriages' of East Mill, who stripped out the machinery. The building was sold to the borough council the following year, and was demolished in the 1950s. Bourne Mill, below, was first recorded around 1240. Its millpond was St John's abbey's fishpond. It worked until 1935 and, soon after in 1936, was given to the National Trust. The surviving house was built as a fishing lodge in 1591 by Thomas Lucas. The ornate gables are in the style which was fashionable in the Low Countries in the later sixteenth century.

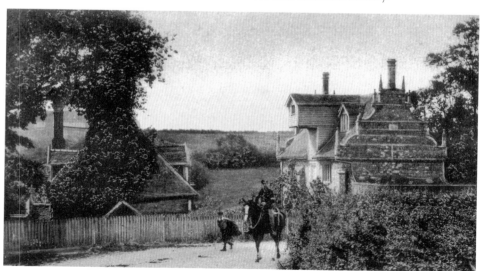

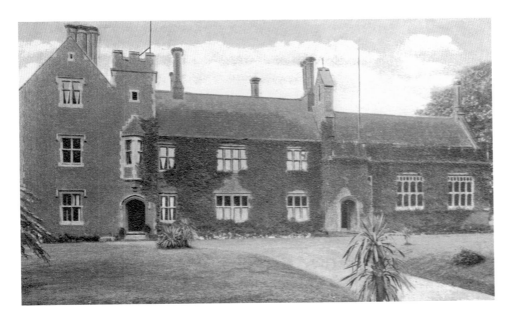

The Colchester Royal Grammar School
Colchester Royal Grammar School founded in 1206 was granted two Royal Charters, one by Henry VIII (in 1539) and another by Elizabeth I (in 1584). The building we see in our postcard was built in the 1850s, replacing a smaller school based at the headmaster's house. Today, the school is one of the best performing in the country and ex-pupils hold fond memories of their time spent there.

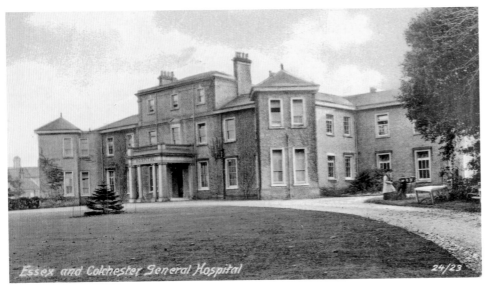

Essex and Colchester General Hospital
The original building was opened in 1820, with an operating room and beds for more than eighty patients in eight wards. Gradually, the building was added to as funds became available, increasing the numbers of beds and standard of service to patients. This view of the hospital dates from before 1907, when it was renamed the Essex County Hospital.

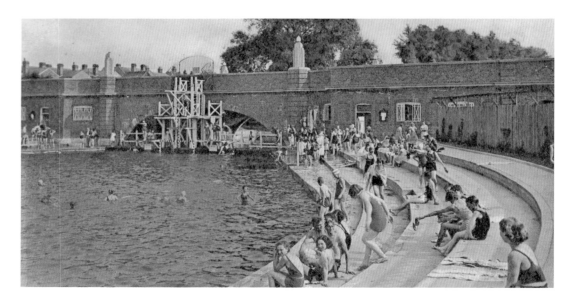

The Open-Air Swimming Pool
When the new bypass road bridged the river at this site in 1933, an open-air swimming pool was provided and was used until 1978, when it was turned into a water sports centre. Today, many Colcestrians remember fun times here vas youngsters.

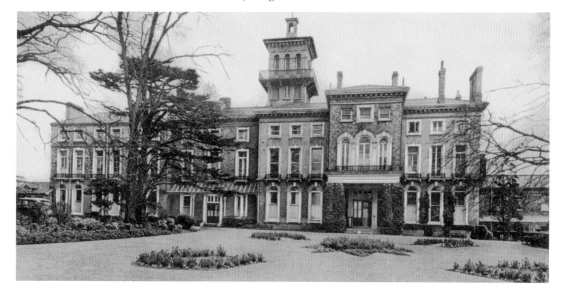

Essex Hall
This wonderful building was built as the Victoria Hotel, in readiness to welcome guests arriving at the new railway station (North station) in 1843. It was a catastrophic failure and the town's businessmen rallied to the assistance of the owner. It became Essex Hall, a place where the mentally ill could be treated. This led to Colchester becoming a renowned regional centre for this kind of groundbreaking medicine, with Severalls Hospital following on and other similar establishments being set up. This building was sadly lost in the 1980s when it was closed down and subsequently demolished.

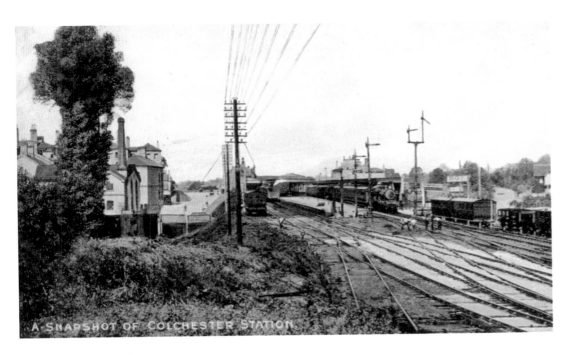

A SNAPSHOT OF COLCHESTER STATION

Colchester Railway

The railway arrived in Colchester in 1843. The view above looks west towards London, with Essex Hall (a failed railway hotel that became the Essex Hall Asylum for Idiots and Imbeciles) on the left, and the station buildings either side of the railway platforms. The card below was posted in 1905, the engine being identified as a Holden E4 (GER T26) 2-4-0.

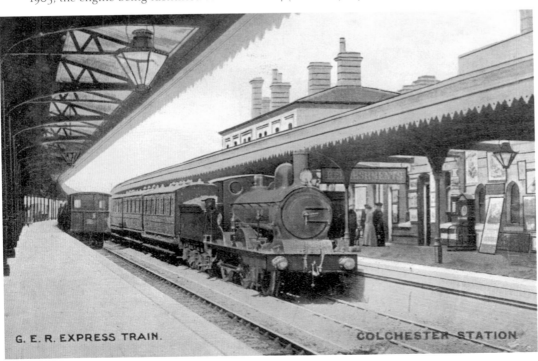

G. E. R. EXPRESS TRAIN. COLCHESTER STATION

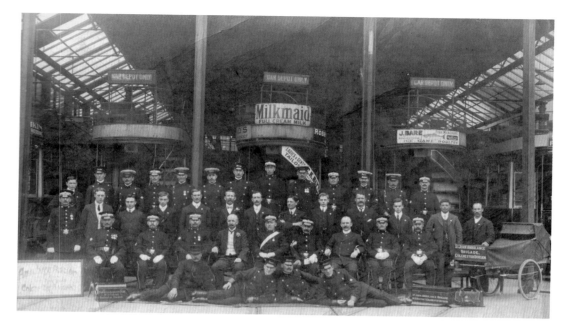

Colchester Trams

Trams came to Colchester in 1904 and took over from the horse buses and general horse-drawn carriages of the time. We have seen plenty of pictures of these trams already, so here we have two pictures from a different perspective. The above image is a gathering of the tramway staff and St John's Ambulance personnel in the tram shed on Magdalen Street. Sadly, the trams were not profitable and were replaced by motorised buses in 1928. We have already seen the bus station that was created in St John's Street in an earlier picture. Below, we have one of the trams dressed up for the Coronation of King George V in July 1911.

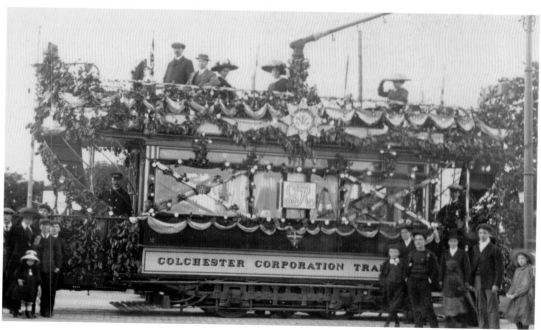

MAPS OF COLCHESTER

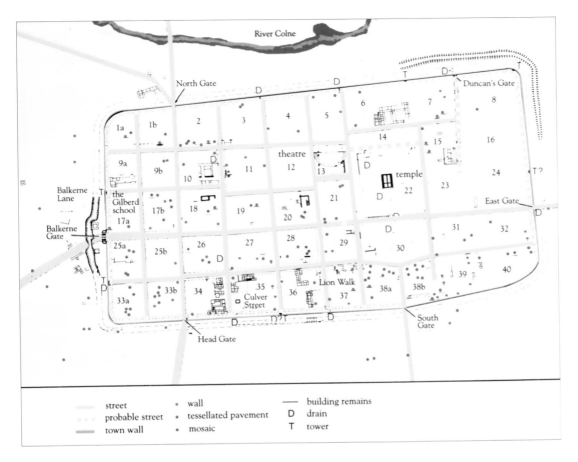

River Colne

North Gate

Duncan's Gate

Balkerne Lane

Balkerne Gate

the Gilberd school

theatre

temple

East Gate

Lion Walk

Culver Street

South Gate

Head Gate

street	• wall	—— building remains
probable street	• tessellated pavement	D drain
town wall	• mosaic	T tower

The Roman Colonia Map, c. 300 AD

This map shows how the Romans developed the colonia during the period from AD 43 until their departure. They left us our walls and the Balkerne Gate, of particular note, and much more besides. From this beginning, our modern-day town evolved into something far bigger than the Romans could surely ever have imagined. This map shows the various features, road layouts, gates, buildings and drains that archaeologists have discovered. Many of our roads today follow those of Roman times. (*Map reproduced with the kind permission of the Colchester Archaeological Trust*)

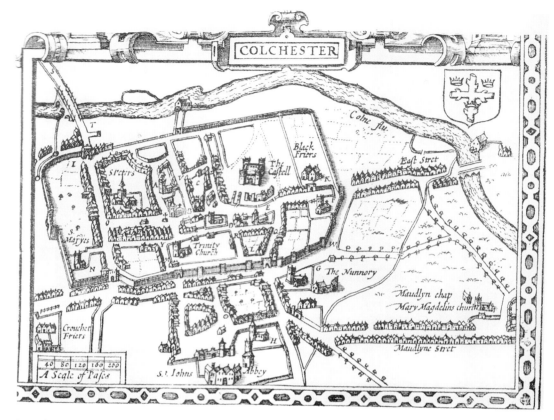

The John Speed Map of 1610

This map shows how the town had developed by the seventeenth century. Of particular note is the expansion outside the walls to the south and east. Our postcard views show many of these buildings, particularly the castle, the churches and many of the timber-framed buildings of that time.

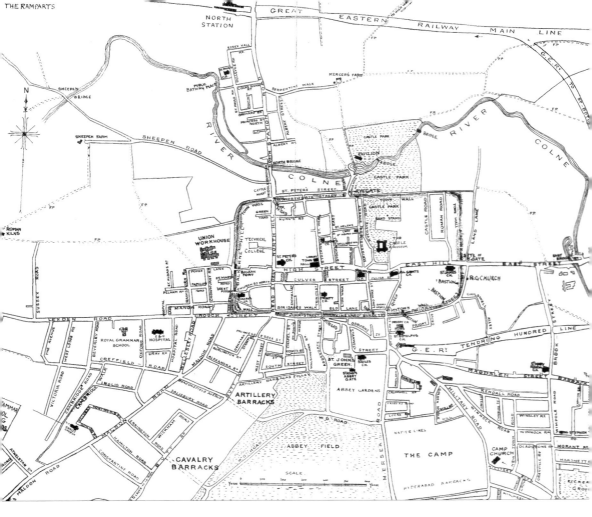

Benham's Map of c. 1925

The above map has been taken from *Benham's Guide to Colchester*, dated around 1925. It is therefore, contemporary with most of the postcards in this book. Not shown, are Lexden to the west, or the Hythe to the east. What is striking from our maps is the presence of the Roman wall around the town. 2800 metres long, 6 metres high, 2.4 metres thick. What an achievement that was!

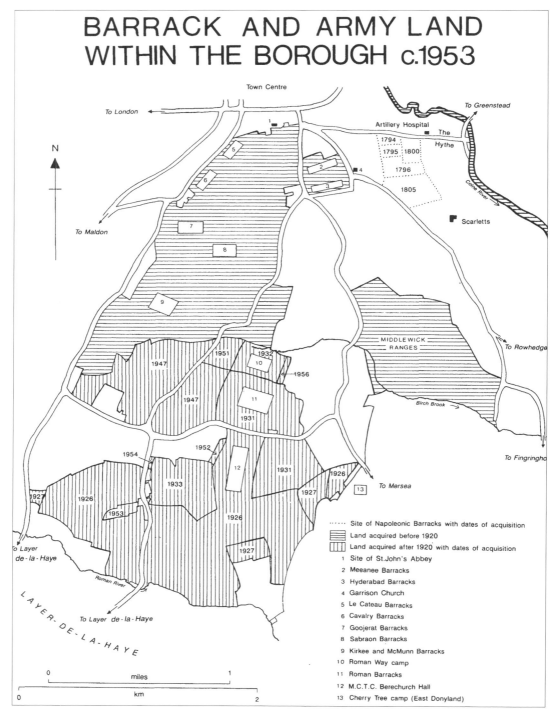

BARRACK AND ARMY LAND WITHIN THE BOROUGH c.1953

Town Centre

To London

To Greenstead

Artillery Hospital

The Hythe

1794
1795 1800
1796
1805

Scarletts

N

To Maldon

1
5
2
4
3
6
7
8
9

MIDDLEWICK RANGES

To Rowhedge

1951
1932
1947
10
1956
1947
11
1931
1952
1954
12
1931
1926
1933
1927
13
To Mersea
1927
1926
1927
1926
1953

Birch Brook

To Fingringhoe

To Layer
de-la-Haye

Roman River

LAYER-DE-LA-HAYE

To Layer de-la-Haye

Colne River

········ Site of Napoleonic Barracks with dates of acquisition
▦ Land acquired before 1920
▥ Land acquired after 1920 with dates of acquisition
1 Site of St.John's Abbey
2 Meeanee Barracks
3 Hyderabad Barracks
4 Garrison Church
5 Le Cateau Barracks
6 Cavalry Barracks
7 Goojerat Barracks
8 Sabraon Barracks
9 Kirkee and McMunn Barracks
10 Roman Way camp
11 Roman Barracks
12 M.C.T.C. Berechurch Hall
13 Cherry Tree camp (East Donyland)

0 miles 1
0 km 2

This map was copied from *A History of the County of Essex: Volume 9: The Borough of Colchester.* Hopefully, it will give some assistance with locating the positions of the military garrison postcard views that are included within this book.

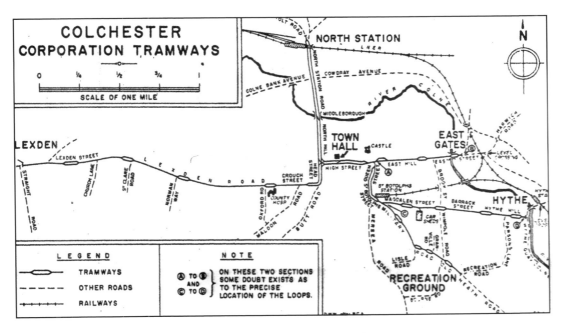

Colchester Corportation Tramway Routes, 1904 to 1928
As we have so many views of the trams, this map gives an idea of their routes across the town.

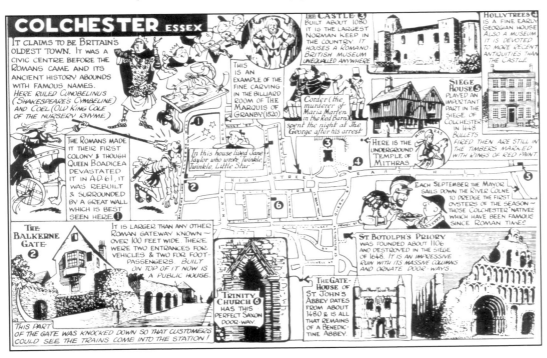

A Postcard Map – With a Touch of Humour
The postcard above is a light-hearted look at a map of Colchester, published by Colchester and Essex Museum, cartoon by Peter Jackson. Date unknown.

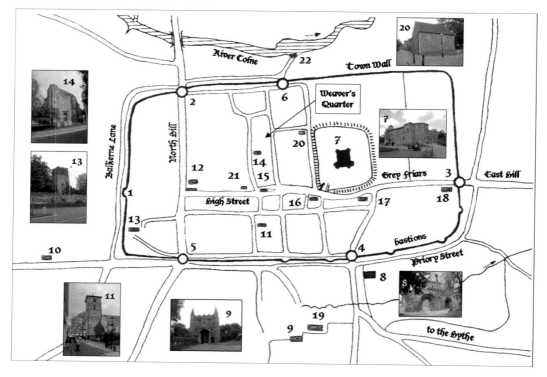

A Map of Selected Heritage Sites in Colchester Today

1. Balkerne Gate – one of the five main gateways into the Roman colonia. This one faced London but seems to have been given up at some point and baulked, stopped up and filled in during antiquity, by whom and when, we know not. This led to the High Street being cut short and the saviour of this most ancient of edifices.

2. North Gate – another of the five gateways, the last trace of which disappeared in the mid-nineteenth century.

3. East Gate – as before, this gate is recorded as having fallen down in 1651, a few years after the Siege of Colchester in 1648.

4. South Gate – As with the others, this gate was gone by 1818.

5. Head Gate – so named, presumably, because it became the main access way to and from London, replacing that of the Balkerne Gate. It was removed in the middle of the eighteenth century.

6. Rye Gate – as far as we know, this was never a Roman gateway. What we see today is a creation of the Victorian Age, giving access to our wonderful, award-winning Castle Park. This gateway would have given easy access from the Norman period, most probably, when a water mill (known as Middle Mill) was built nearby.

7. The Norman Castle – William commanded that castles be built across the length and breadth of his new domain of England. Eudo Dapifer built the largest Norman keep that ever was. It had to be large, as this Norman baron decided that his castle should embrace the podium of the Roman Emperor Claudius' temple that stood here. Eudo was responsible for many other buildings in

the borough. His problem was a lack of natural building stone. Colchester had none. What it did have, though, was a walled citadel, 'built by giants', that was filled with crumbling and decayed buildings from an ancient time before. And so it was that the Normans efficiently destroyed Roman Colchester by 'harvesting' the materials used by the Romans, but without touching the all-important walls. His castle keep was surrounded by a bailey system of earthworks that spilled out to the south. Its expansion was sufficient to require the old, straight, Roman High Street to be reshaped.

8. St Botolph's Priory – with the Normans came Christianity of an all-powerful Catholic Rome variety. Completed around 1105, this is the first Augustinian priory that was ever built in England. It holds ascendancy over all others. Made redundant by Henry VIII during reformation and much damaged during the Siege of Colchester, its shell now stands as a much loved monument and an illustration of the recycled Roman materials from which it was constructed. Close by stands St Botolph's church, an early Victorian replacement (in the Norman style) of the earlier church.

9. St John's Abbey – this Benedictine abbey was founded by Eudo in 1096/07, although only the fifteenth-century gateway and much of its perimeter wall still survives.

10. Crouched Friars – we have a priory and an abbey, but we also had two friaries. Archaeological explorations have confirmed the location of Crouched Friars, but Greyfriars (near East Gate) has not yet been clearly located. Both have been lost to us.

11. Holy Trinity – the tower of this church has been dated to the Saxon period c. 1000. Whether or not it started life as a lookout tower and was converted to a church at a later period, is a matter of discussion, although it was added to a much earlier building, now lost. The arrow-shaped doorway, constructed from reused Roman materials, is typical of the period, as are the windows.

12. St Peter – this church is the only one that appears in the Domesday Book of 1086, and therefore claims ascendancy over all the others. As with the various other churches, its modern day fabric is of a much later period than the original church that must once have stood here.

13. St Mary at the Walls – this ancient church stands next to our Roman wall and is now deconsecrated and used as an arts centre. It is associated with the famous Humpty Dumpty nursery rhyme.

14. St Martin – this became the church associated with the Flemish weavers and sits within the Weavers' Quarter among the many ancient timber-framed buildings that have survived the centuries. Its graveyard has a seventeenth-century grave with a tombstone to one of the last of the baise makers (or bays and says), Jacob Ringer.

15. St Runwald – this church used to stand in the High Street, near to our present-day town hall. It was demolished in the 1850s, although its graveyard still exists a distance away, behind the hall.

16. St Nicholas – this church once stood in the High Street, but was demolished in the 1950s.

17. All Saints – this church became our present day Natural History Museum.

18. St James – to the east, built close to the Roman East Gate, this church is very much in use today as a place of worship (as is St Peter's on North Hill).

19. St Giles – this church was provided by the abbot of St John so that the people of his parish could worship without having to come in to the abbey grounds. It is now a masonic lodge. See also St Botolph (mentioned earlier), St Leonard at the Hythe (Hythe Hill) and St Mary Magdalen (in Magdalen Street and at one time associated with the medieval leper hospital, all now mostly gone).

20. St Helena Chapel – this was a chantry chapel, where a priest was paid to say prayers for the deceased for as long as the money lasted. We know that it was repaired in 1097, that it was

dedicated to our patron saint St Helena and that it was built on top of a foundation wall of one Roman theatre. It is now used for worship by the Greek Orthodox Church.

21. The Moot Hall – this is probably where the ruling Romans had built their main administration building, the site of which was later (in medieval times) the location of a grand timber-framed edifice known as Moot Hall. That building was demolished by the Victorians and our present day town hall stands on the spot.

22. Middle Mill – this was just one of several mills (water and wind) that used to exist in medieval times for various uses, but particularly for the grinding of corn or for the various processes required by our hugely important cloth trade. Only the weir and mill pond still exist today.

The map and the accompanying information, has been taken from a Camulos leaflet which used to explain to visitors where some of the modern-day heritage sites could be seen.

SOURCES AND ACKNOWLEDGEMENTS

The author has been collecting Colchester postcards for many years as a part of his interest in the whole spectrum of Colchester's rich heritage. Almost exclusively, these postcards have been purchased via the internet. However, a few of the postcard images that are included in this book have been donated by other collectors of postcards. In particular, images from Mr Kevin Bond, Mr Alex Jones and Mr Simon Gallup have been used. The historical information that accompanies the images has, in the main, come from the author's accumulated knowledge drawn from many years of study, but with key facts being confirmed with information gleaned from *A History of the County of Essex: Volume 9: The Borough of Colchester*. An intimate knowledge of the modern day town, which the author has built up through the numerous guided walks that he conducts each year, has been invaluable when identifying changes over the past century. Further information from members of the public who have accompanied the author during these walks has also added to the stories, which have been written here and recorded for posterity.

THE AUTHOR

Jess Jephcott was born in Barnet, Hertfordshire, but, from the age of two, he grew up in the seaside town of Walton-on-the-Naze. He became an engineering apprentice at a leading industrial fan manufacturing company in Colchester. Having lived in Colchester for many years, he now lives in the village of Fordham, but still within the Borough of Colchester. From a very early age, he was interested in all things historic and ancient, and is a member of various local archaeological and historical groups, regularly delivering lectures on a variety of Colchester-themed subjects (sometimes while dressed as a first-century Roman soldier). In 1995, he published his first Colchester book, *The Inns, Taverns and Pubs of Colchester*, now in its fourth edition. In 1998, he created the Camulos website that deals with many aspects of Colchester life, particularly its heritage. This is a work in progress that is constantly being updated and expanded. Images from his postcard collection, which contains more than 1,000 items (some of which can be found in this book), is also to be found at Camulos. In 2000, he was a founding member of the Colchester Town Watch, an Elizabethan period recreation of the town's system of policing, but which has now evolved into being the civic bodyguard to the mayor of Colchester.